A POCKETFUL OF CONTEMPORARY ARTISTS

Photographic Portraits
by **Sebastian Piras**

A POCKETFUL OF CONTEMPORARY ARTISTS

Photographic Portraits by **Sebastian Piras**

Published in Australia in 2008 by
Peleus Press
an imprint of The Images Publishing Group Pty Ltd
ABN 89 059 734 431
6 Bastow Place, Mulgrave Victoria 3170, Australia
Tel: +61 3 9561 5544 Fax: +61 3 9561 4860
books@imagespublishing.com
www.imagespublishing.com

National Library of Australia Cataloguing-in-Publication entry:

Piras, Sebastian.
A pocketful of contemporary artists: photographic portraits.

Bibliography.
ISBN 978 1 86470 293 4 (hbk.).

1. Artists - Portraits. 2. Artists - Pictorial works. I. Title.

779.2092

Coordinating editor: Andrew Hall

Designed by The Graphic Image Studio Pty Ltd, Mulgrave, Australia
www.tgis.com.au

Digital production by Splitting Image Colour Studio Pty Ltd, Australia

Printed by Everbest Printing Co. Ltd., in Hong Kong/China

IMAGES has included on its website a page for special notices in relation
to this and our other publications. Please visit www.imagespublishing.com.

Contents

Foreword

It is an absolute truth that all photographic portraits are
fictions of one sort or another. Even if the fiction is relatively
factual, the picture remains—above every other thing it is—
essentially a social contract.

As sitters, you begin the process with a set of questions in
mind. Who do you want to be? Who do you think you are?
Who's in control here? Portrait photographers have an
overlapping set of questions. Who is this guy? Who does he
think he is? Who does he think I think he is? And of course,
who's in control here? As such, portraits are records of complex
negotiations between parties with conflicting interests.

Portraying artists raises the stakes considerably. In our mind's
eye the image of an artist is a merger of the memory of their
work and of how they looked. Not just how they appeared in
a photograph, but how they gaze back at us—how they meet
and contain the camera's relentless assault on their identity.
Thus, the negotiation between the artist and the photographer
involves a totally different set of inventions, which has to do
with the ways in which artists choose to allow their portrayal.

Issue of simple vanity aside, many artists are enormously concerned with their resemblance to the idea created by their work. And even when simple vanity is the case, the negotiation remains complex. The payoff is that the result of these contested portraits can be spectacular.

In Sebastian Piras' probing and extraordinarily beautiful portraits of artists we see the direct results of this special kind of photography. And we learn that Piras not only has a profound ability to create compelling pictures, but that he has the ability to engage a wide range of fellow artists in a contest that ultimately produces winners on both sides of the camera.

David A. Ross

Interview

Sebastian Piras and Judd Tully discuss the
inspiration and technique behind Piras'
photographic portraiture.

Judd Tully: What initially inspired you to take photographic
portraits of artists? When did that begin and do you recall
your first subject?

Sebastian Piras: I started taking photographs of artist friends
while I was still living in Italy back in high school. I never
thought of it as an inspiration or project until I moved to New
York City from London in the mid 1980s. I photographed Robert
Mapplethorpe in his studio and he invited me to an opening
reception of his photos. There I met Warhol and asked if I could
photograph him. I took his picture on several occasions and he
suggested that I take more photos of artists and possibly print
them in *Interview* magazine. I didn't take many as I was busy
working on other projects—and then Warhol died. A few years
later, while I was spending more time in East Hampton, I started
taking photographs of artists again since I had lot of neighbors
who were artists—Ross Bleckner, Eric Fischl, and John
Chamberlain, to name a few.

JT: Once you're in the artist's studio and have his or her
undivided attention, what is it you're trying to capture or convey?

SP: I never really have a plan, per se, when going to the artist's
studio; I don't do anything gimmicky or conceptual when
taking these portraits. I have always preferred to shoot as

soon as I can after I get there: I like that energy that sparks from the first impact of meeting somebody, be it discomfort, nervousness, or ease—it's all great material. My main goal is creating a visual record of my encounter with these subjects.

JT: Historically speaking, which photographers do you admire or think about who've taken photographs of artists? Perhaps Man Ray or Brassai or David Douglas Duncan?

SP: Brassai's images were certainly beautiful. When it comes to artists' portraits there's certainly quite a history of photographic portraits of artists, many photographers have ventured that way, each one with their own distinctive style and approach. Francois Meyer, a Swiss collector and an accomplished photographer of artists himself, has assembled a great collection of artists' portraits—of which I was honored to be a part of—ranging from the great portrait photographer Arnold Newman to Gianfranco Gorgoni and Michael Halsband. Hans Namuth created some of the most important artists portraits of the 1950s and 60s, and Robert Mapplethorpe in his own unique way captured several artists in his own studio. Of course, Man Ray's artists portraits, and his photos in general, were just brilliant, and Helmut Newton, although better known for his nudes, also took portraits of several artists in his unique style. Phillip Hallsman's collaboration with Dali was amazing, and Gottfried Helnwein took some stunning pictures of Warhol. In yet a different style, Ugo Mulas created great documents of the New York art scene in the 1960s, and Alexander Lieberman, an artist himself, did intimate photographic studies of artists studios. However, I am particularly fond of John Deakin, the English

photographer who used to hang out with Francis Bacon. Although he produced only a small body of work, Deakin created some truly intense, if not disturbing portraits of his London circle of artist friends.

JT: Do you feel part of that so-called tradition?

SP: I don't think I could make that statement. To quote Groucho Marx: "I don't want to belong to any club that will accept me as a member!" I surely belong to a group of photographers who are somehow attracted to the process of photographing artists. If anything, it would be interesting to know why that happens. Artists certainly are a seductive subject for photographers, yet the motivation to immortalize them still puzzles me. The only answer I might have is that artists seldom have a clear idea of how they wish to be portrayed, and the photographer often likes to control the session and portray them in his own way. That conflict can create very interesting results.

JT: Since you started your project in New York City, probably at a time when the art world was a very different kind of place (certainly pre-Chelsea), what changes have you noticed from your side of the camera?

SP: In the mid 1980s, when I first came to New York City, I thought the city was really wild. I think that some of the city's main "industries"—Wall Street, fashion, music, and art—were at an optimal point of convergence; Warhol was somewhat of a pivotal figure then and was great at bringing those groups

together. Clubs were also very involved in the process: I remember the Palladium, the club on 14th Street, that had a great show of Robert Mapplethorpe photographs. But the main element that I think might differentiate then from now is real estate, and that doesn't seem to be a reversible cycle at this point. There's no way for young artists to be able to get large spaces where they can work and perhaps live, so a lot of the art in New York City now is actually produced elsewhere. Some 15 or 20 years ago there were still many affordable areas in the city and the artists could actually work in the communities where the art was being shown. Other cities like Los Angeles have become a good mecca for young artists and have a rather vibrant artistic community; however, like it or not, I think that Wall Street and the big corporations based here in New York City are pivotal factors as to why the arts business in this city is so strong—they pour quite a bit of money to support the art institutions.

JT: Are artists now more guarded or less available for sessions in their studios?

SP: There is definitely more weariness on the part of some artists, mainly younger ones. I think that's partly created by the more enhanced business environment in the arts. There may be a fear of being overexposed and of taking the wrong step in the effort to "make it" in that complex maze that is the New York art industry.

JT: In other words, is it harder now to capture your prey?

SP: There have been instances where I was told by certain artists that they didn't want to be photographed, and I totally respect that answer as much as I respect a positive one. But some artists raise the issue of not being exposed for privacy purposes, yet then I see them in *Vogue* or other trendy magazines with articles about their homes, etc. At the same time, I am not that concerned when someone says no, because I understand that being photographed requires a certain effort on their part; for an artist, time and privacy are extremely valuable.

JT: Does there have to be a chemistry between the subject and photographer or isn't there time for that?

SP: Well there definitely has to be chemistry. However, I accept bad chemistry as much as I accept good chemistry. The problem is when you have a neutral zone—although this seldom happens—and the result is rather plain.

JT: Is there an artist out there that you've always wanted to shoot, but for whatever reason haven't been able to photograph?

SP: I can think of a few. I had been to Willem de Kooning's studio in Springs, East Hampton, on two different occasions, but it was complicated to actually photograph him due to legal reasons. He wasn't well at that time. I also really would have loved to have photographed Francis Bacon. When I lived in London I had a girlfriend who was friends with both Bacon and Lucien Freud, however, I never made it to their studios.

I don't think I was ready for this project back then. But then there have been great portraits of Bacon by several photographers, John Deacon's is my favorite, and Peter Beard also did some that were very striking.

JT: Lastly, has your technique or approach changed very much since you started taking pictures of artists?

SP: Certainly it has. Firstly, I have not been shooting with my medium-format camera as much—I've actually been shooting more and more with a 35 mm digital camera. The result is rather different and so is the interaction. I used to only bring a few rolls of film with me—36 exposures in total—and somewhat forced myself to get the picture in a short time and with few exposures. With digital the whole scenario changes and there's also room for manipulation on a computer. I have also been relying more on available light. Just as the art scene changes, I am open to changing my formats and approach, and find the element of chance an exciting factor in portrait photography.

Judd Tully is a widely published freelance journalist and art critic, and is a long-standing member of the International Association of Art Critics.

Marina Abramović

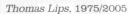

Thomas Lips, 1975/2005

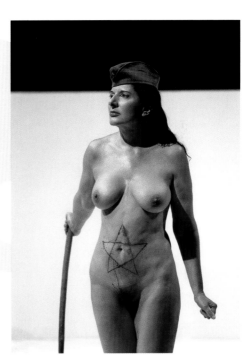

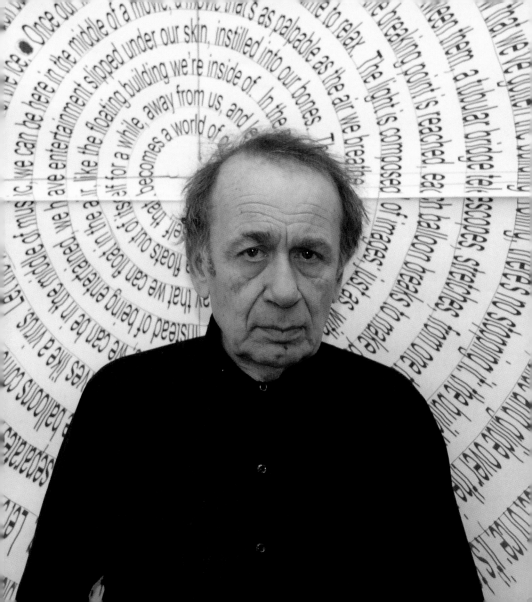

Vito Acconci

Mur Island, Graz, Austria, 2001–03

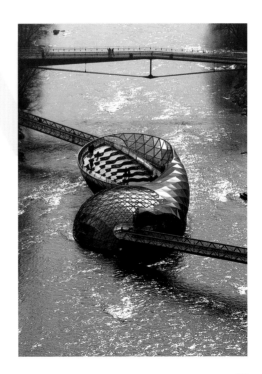

Jurgen Albrecht

Gregory Amenoff

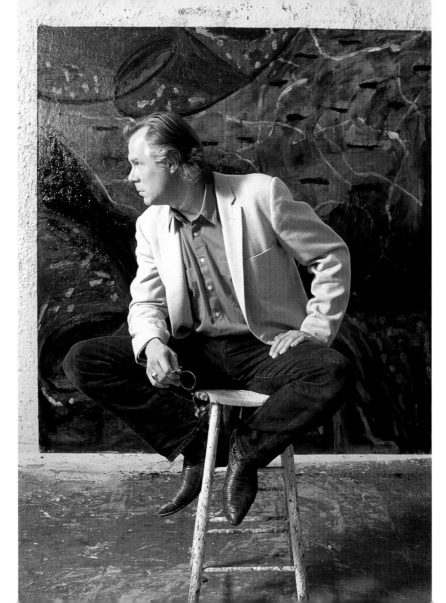

Ghada Amer

Heather's Degrade, 2006

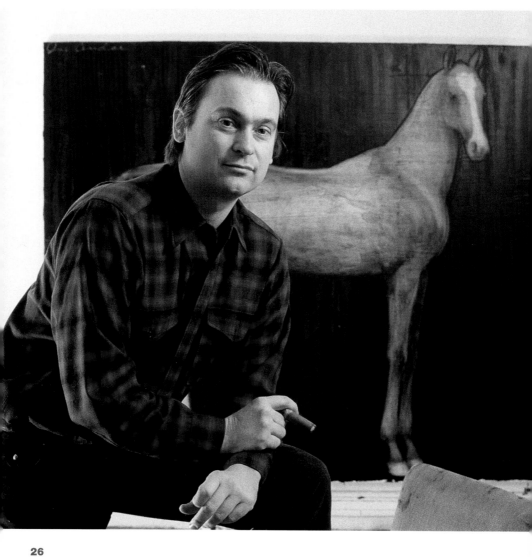

Joe Andoe

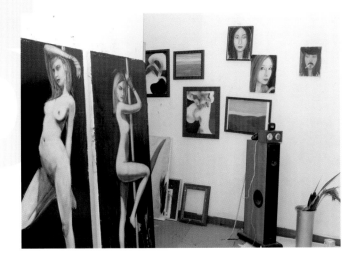

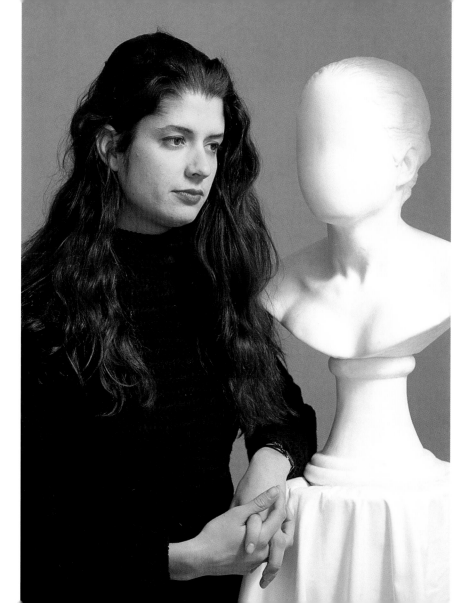

Janine Antoni

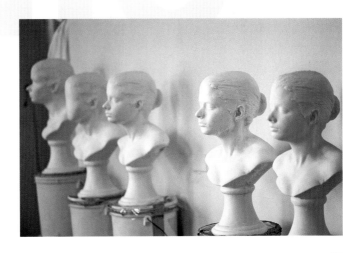

Arman

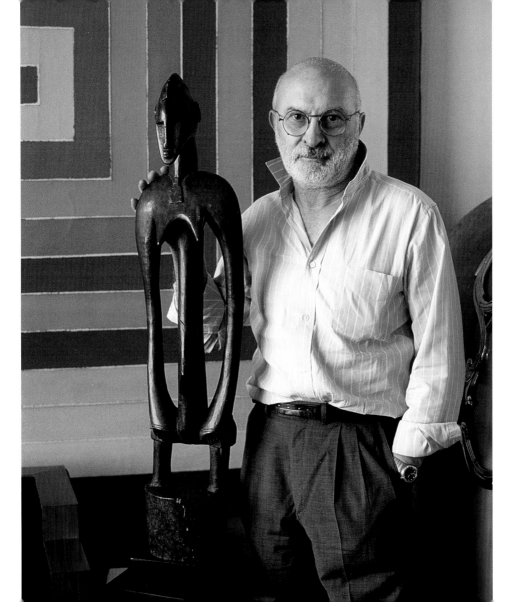

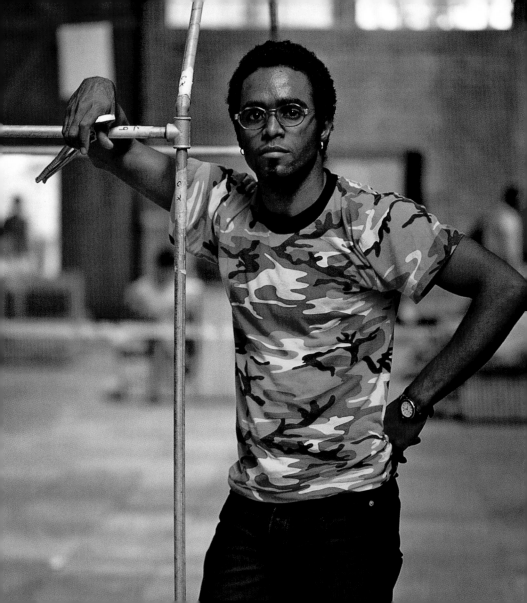

Alexandre Arrachea

Arena (1), 2005

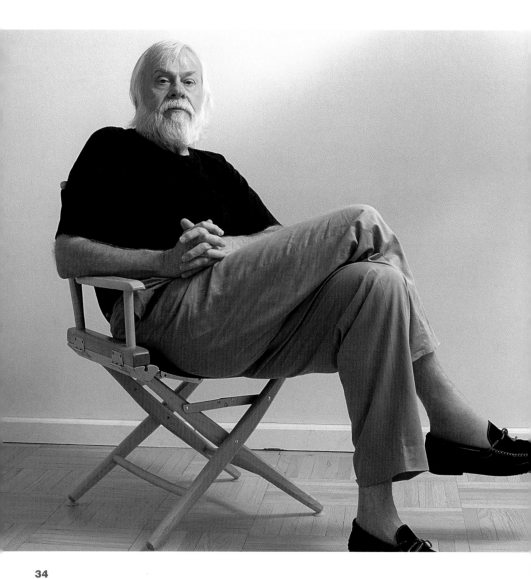

John Baldessari

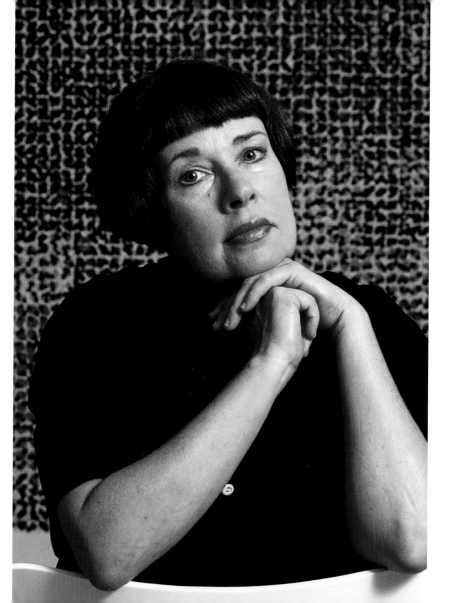

Jennifer Bartlett

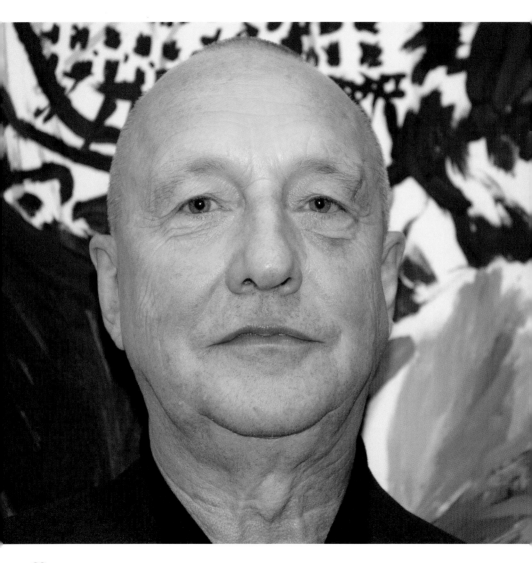

George Baselitz

Bill Beckley

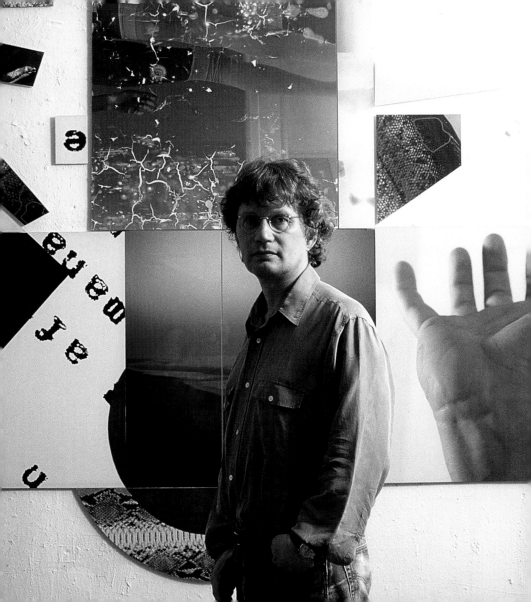

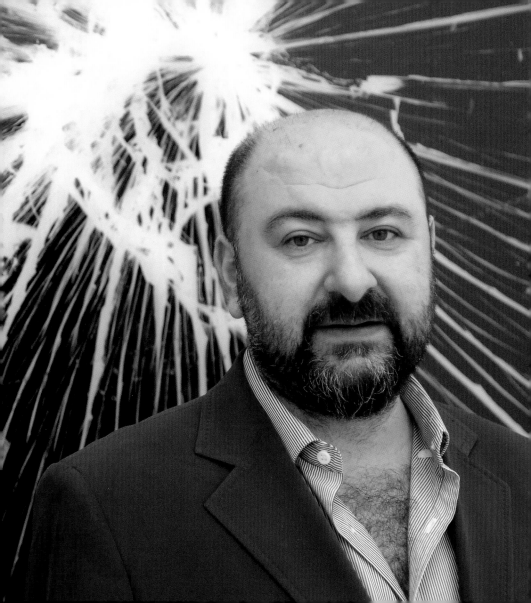

Pierre Bismuth

Most Wanted Men/NYC
(Jeff Koons), 2007

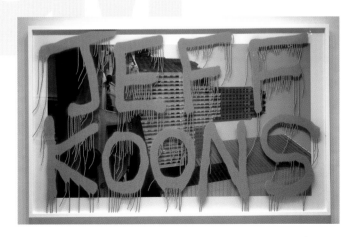

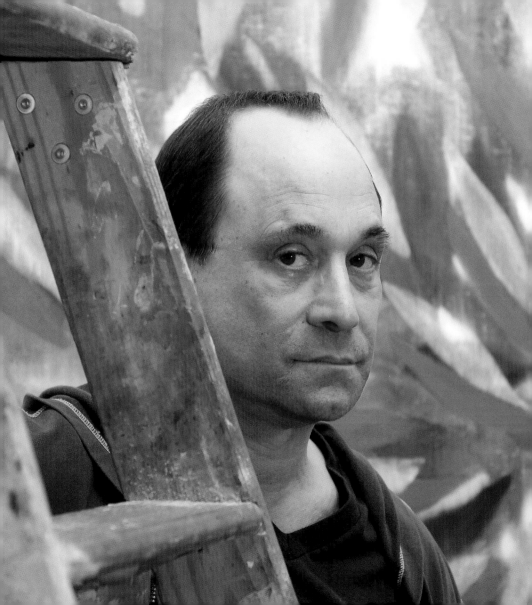

Ross Bleckner

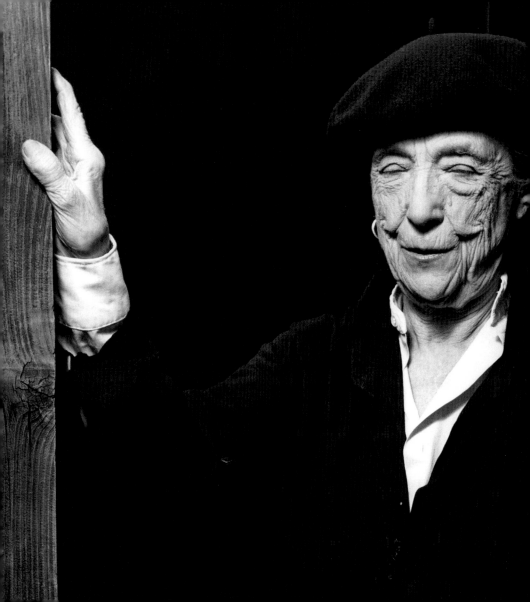

Louise Bourgeois

J'y suis, j'y reste, 1990

Paul Brach

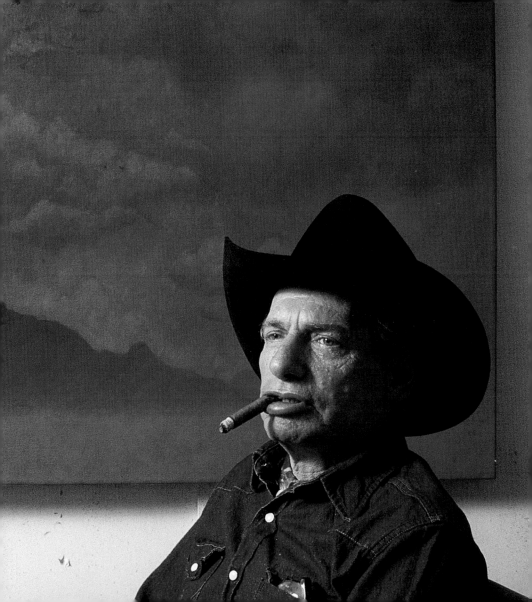

Sophie Calle

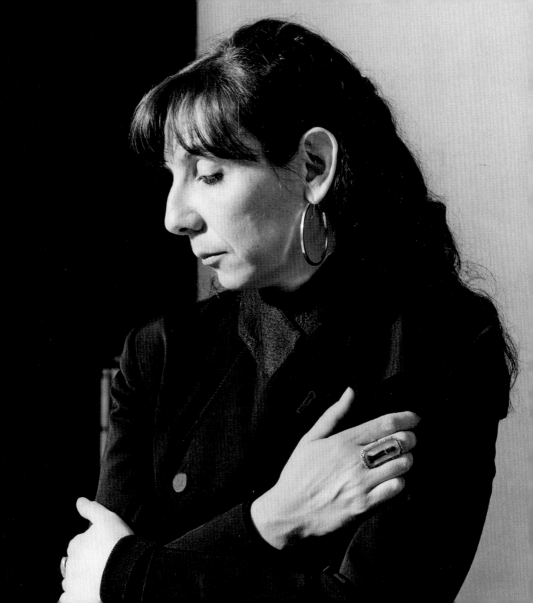

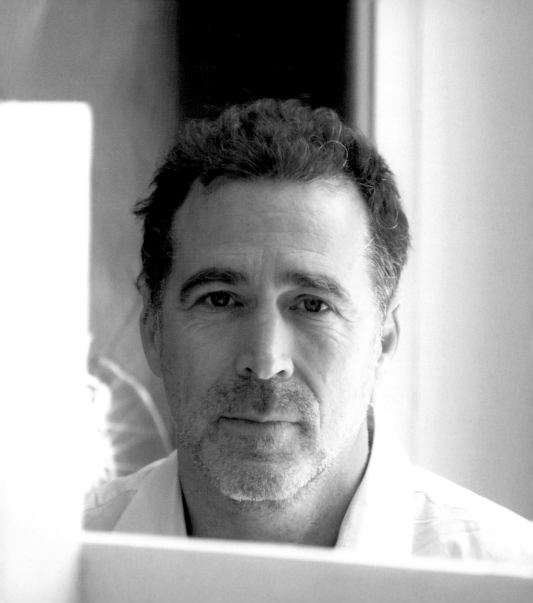

James Casebere

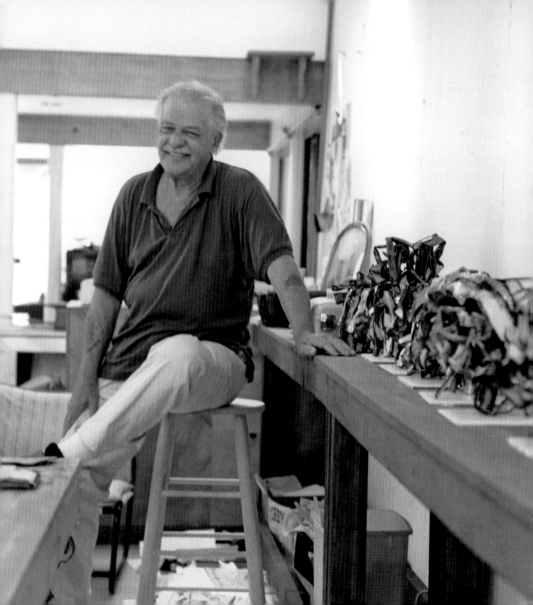

John Chamberlain

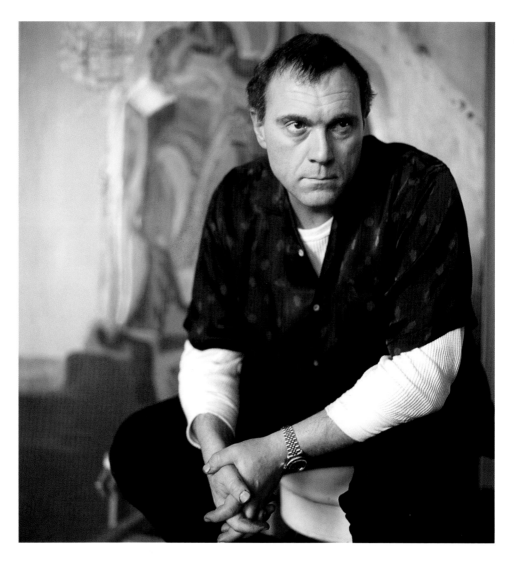

Sandro Chia

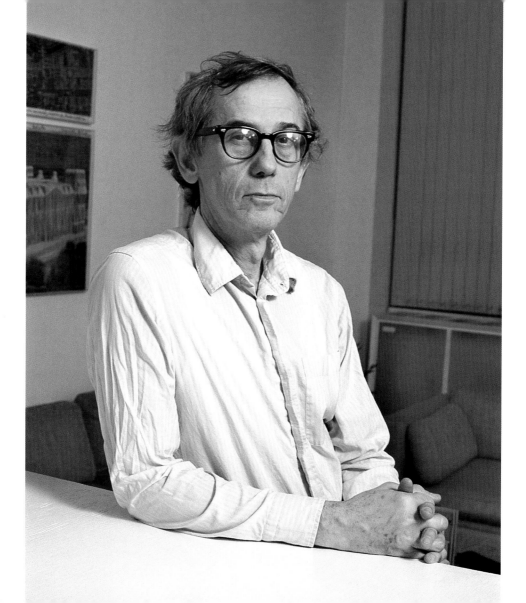

Christo

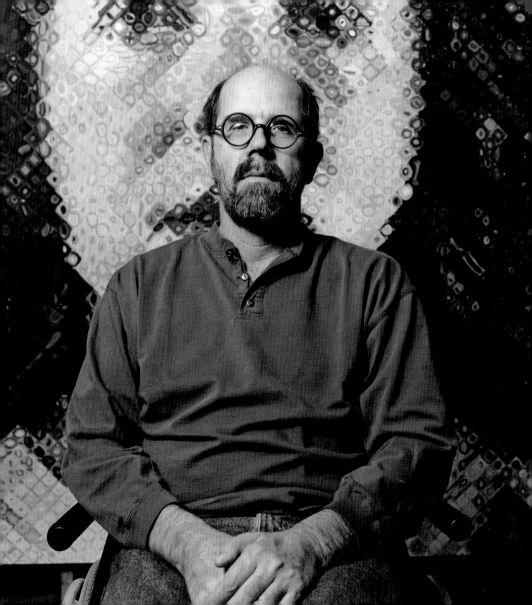

Chuck Close

Quentin Crisp

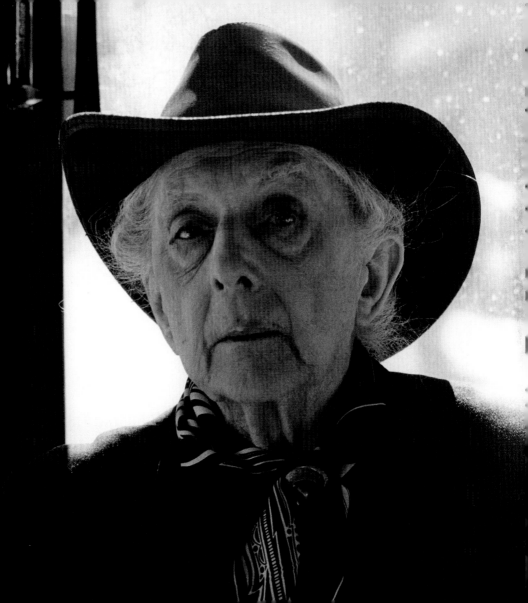

Enzo Cucchi

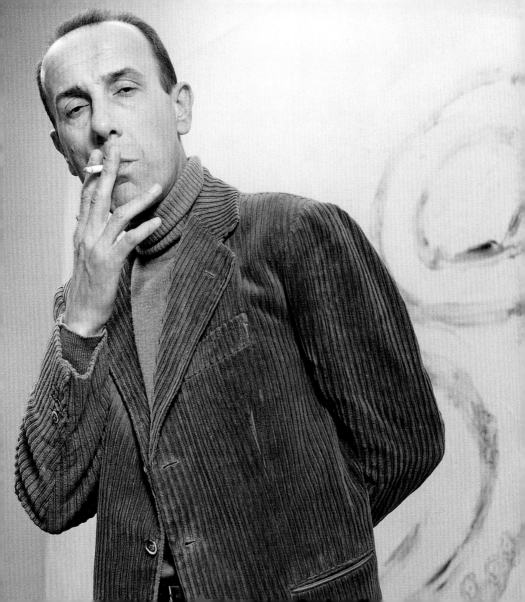

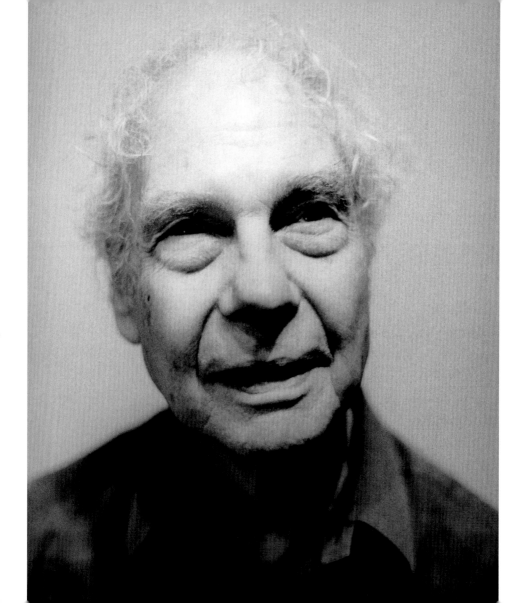

Merce Cunningham

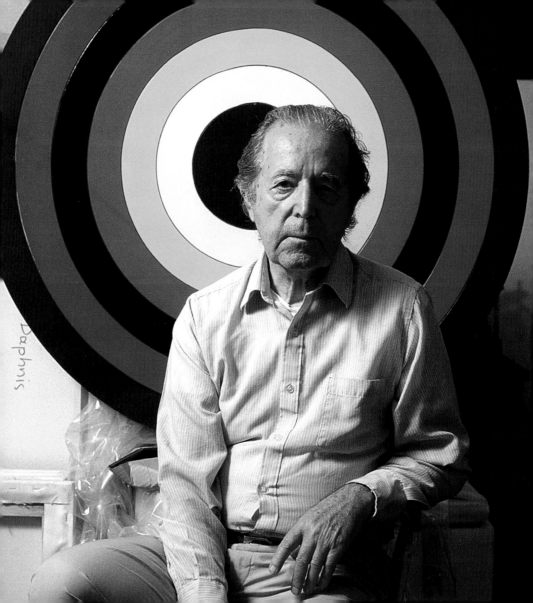

Nassos Daphnis

PX-18-69, 1969

Karen Davie

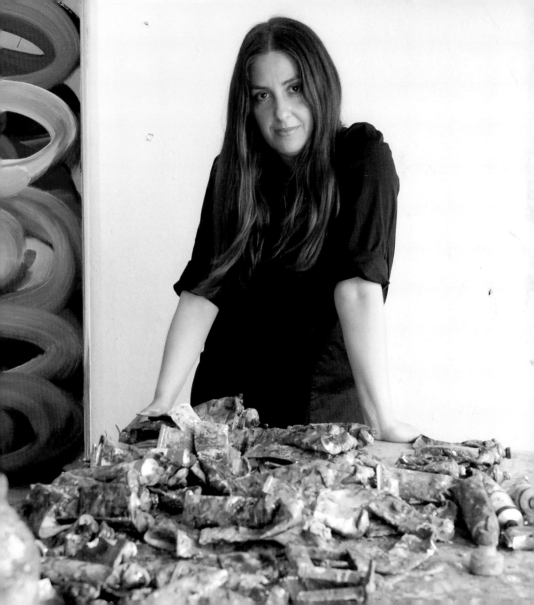

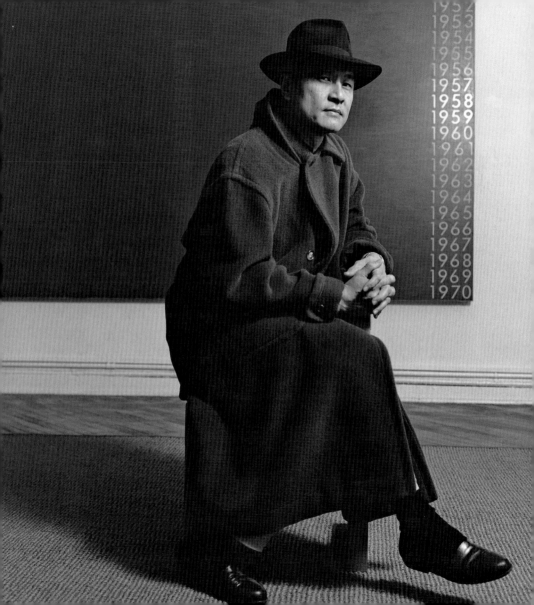

David Diao

Jim Dine

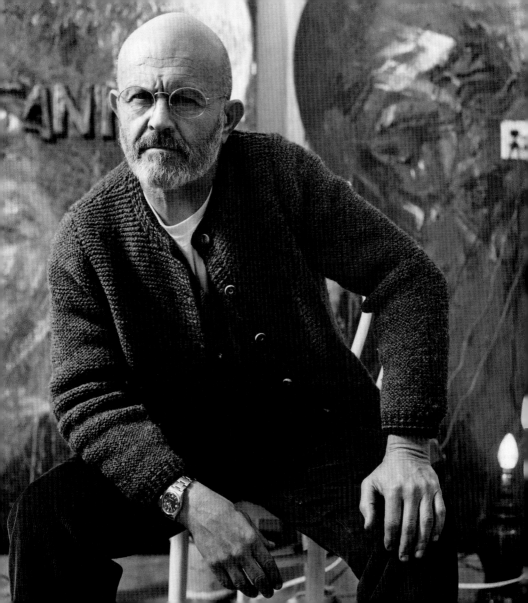

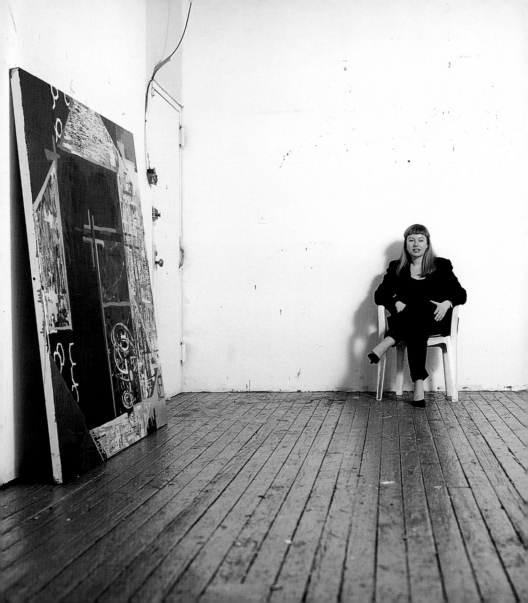

Lydia Dona

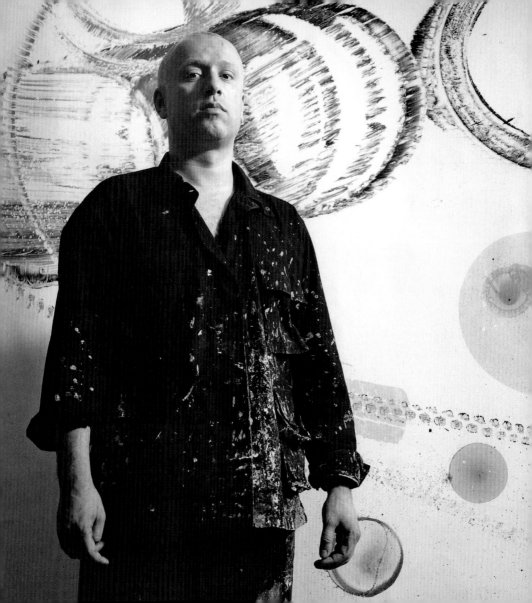

Jiri Jorg Doukopil

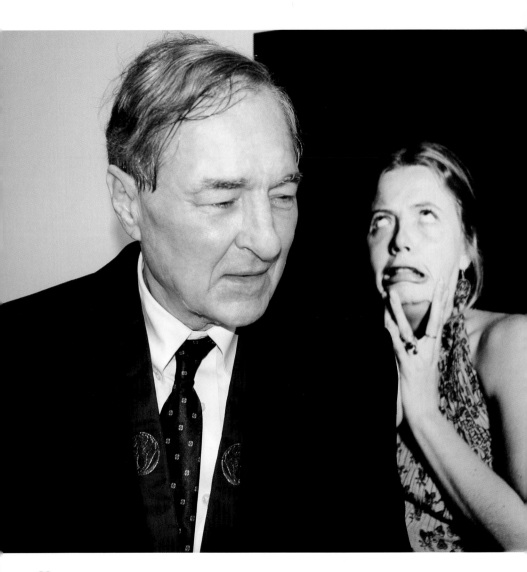

William Eggleston

Untitled, (Store Parking Lot) From Lost And Found, 1965–74

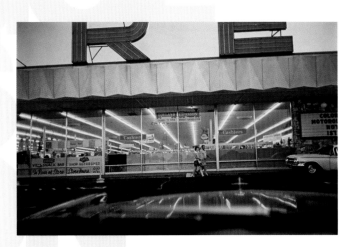

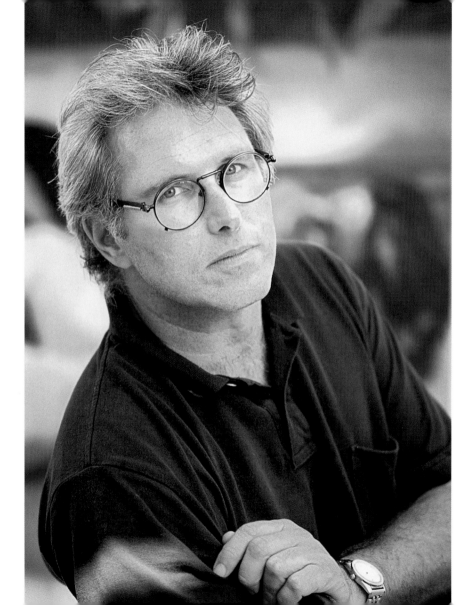

Eric Fischl

The Bed, The Chair, Jetlag, 2000

Dan Flavin

Charles Henry Ford

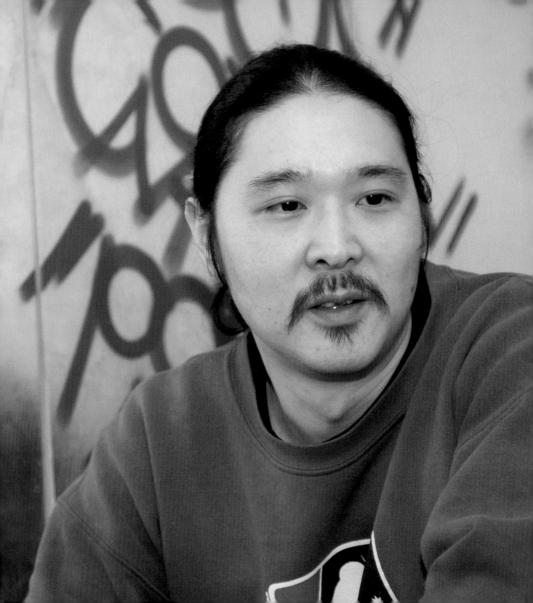

Gajin Fujita

Vincent Gallo

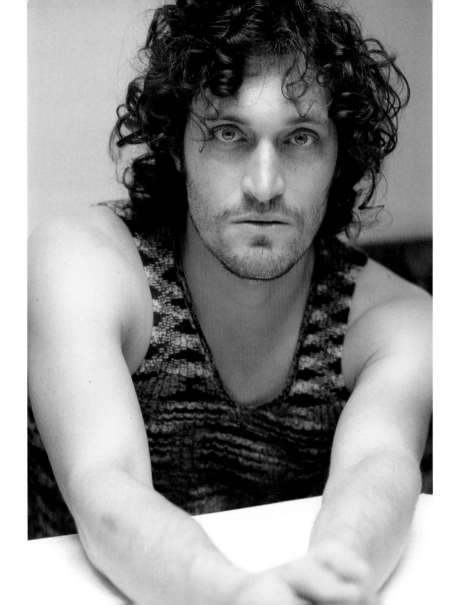

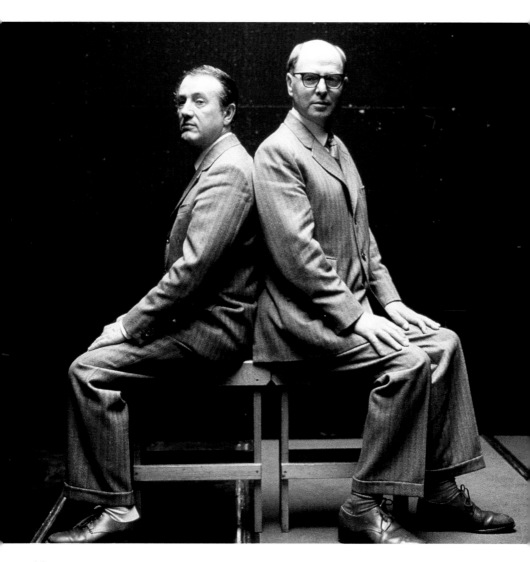

Gilbert & George

Son of a God, 2005

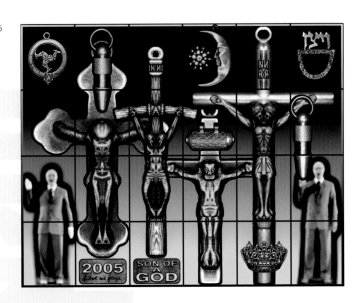

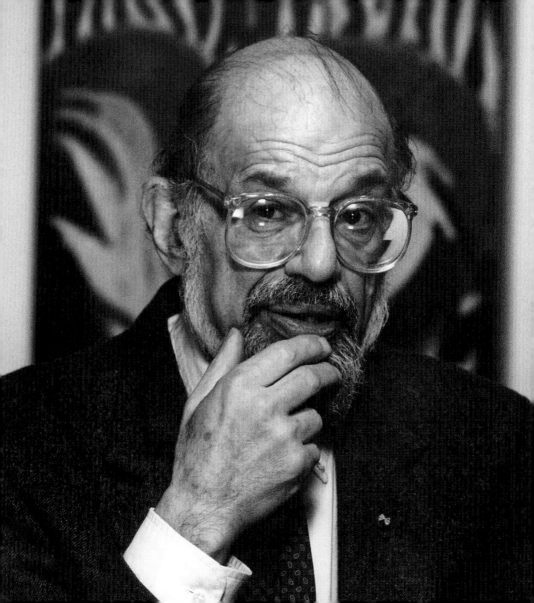

Allen Ginsberg

Window, 1984

I sat for breakfast the morning almost a decade looking out my
kitchen table window, one day realized that was my only world, the five
story backyard view a giant wet brick-walled universe, Atlantic.
New garden varying with a[l]teatherly, cloudworld "trees of Heaven" blossomy.
I like doing without a Bayonne[?] town apartment "Co stairs north,
I focused on the backdrops in the clothesline low it East Side.
Manhattan August 18, 1984 Allen Ginsberg

Nan Goldin

Leon Golub

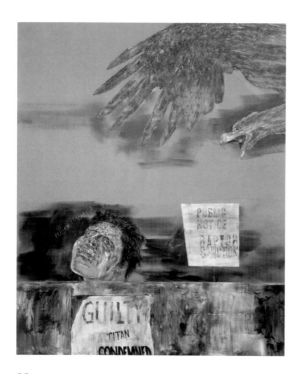

Prometheus II, 1998

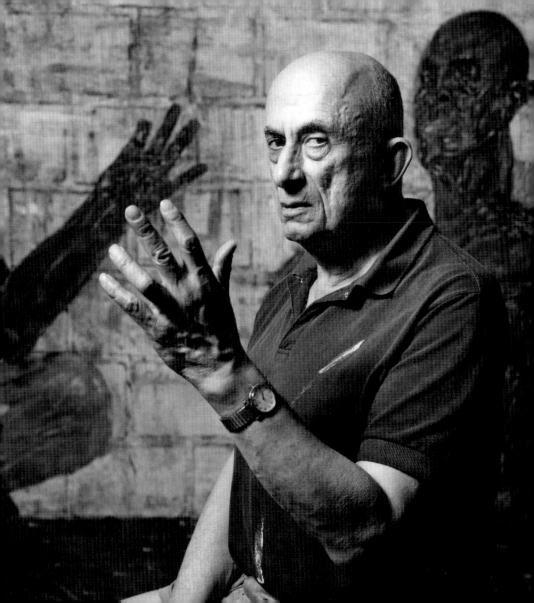

Dan Graham

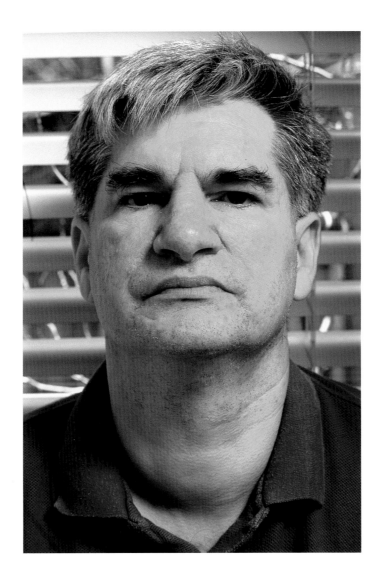

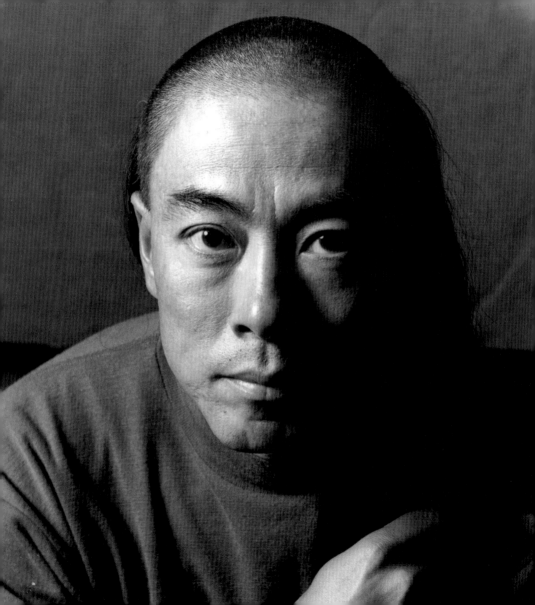

Wenda Gu

Installation at Dartmouth College, 2007

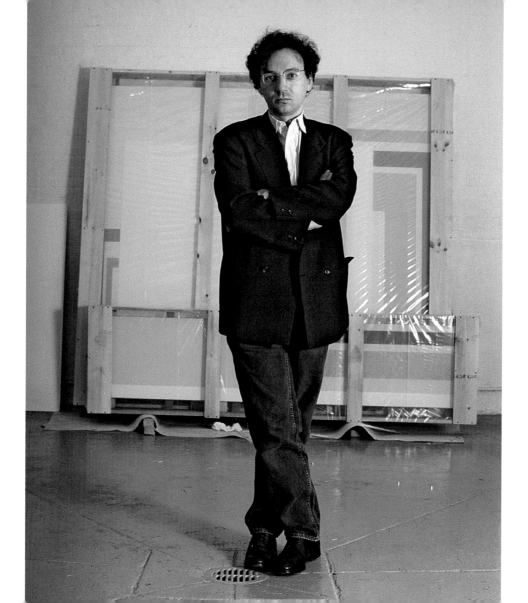

Peter Halley

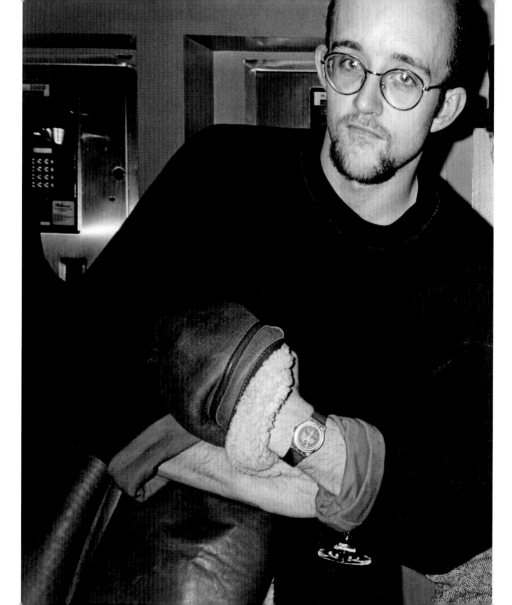

Keith Haring

Damien Hirst

The Physical Impossibility
of Death in the Mind of
Someone Living, 1991

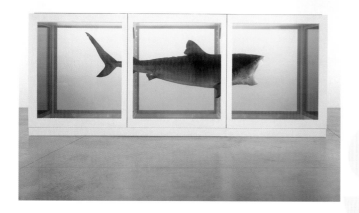

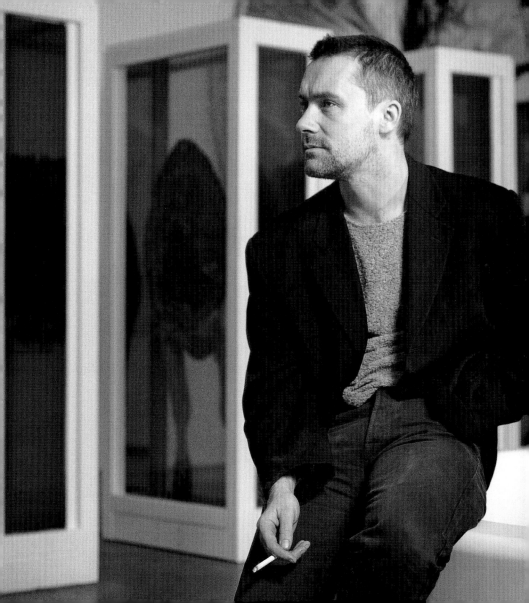

David Hockney

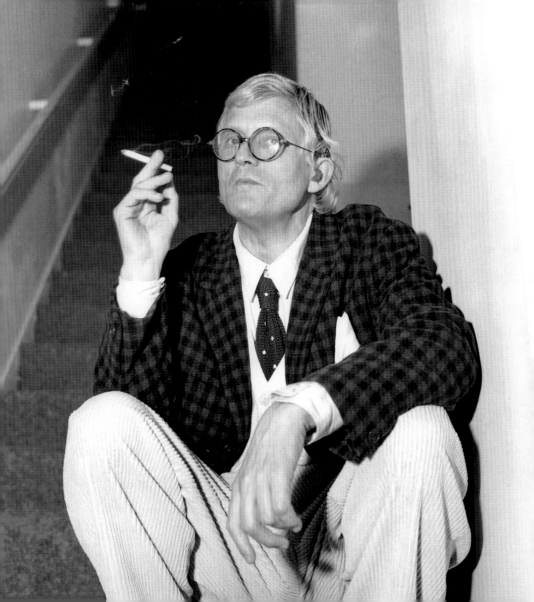

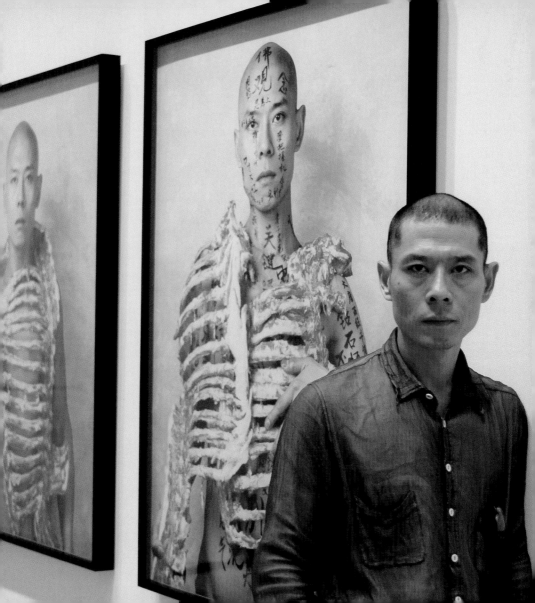

Zhang Huan

Buddha Never Down, 2003

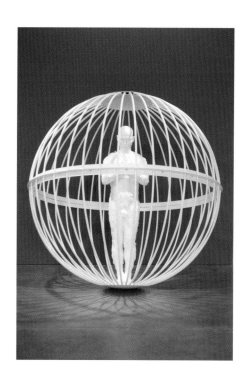

Brian Hunt

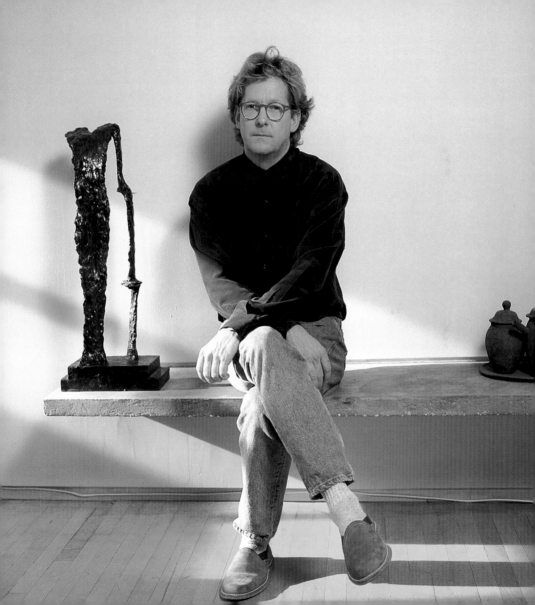

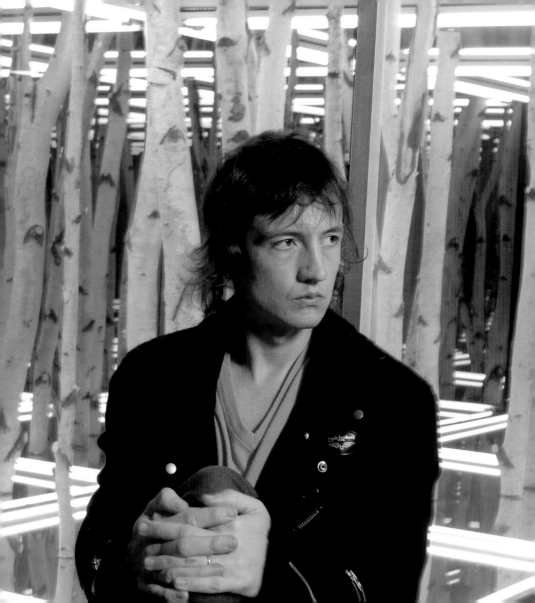

Anthony James

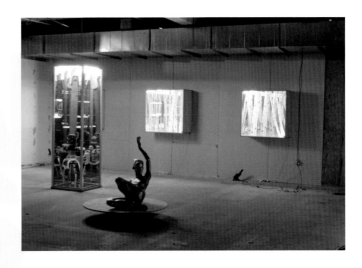

Wang Jin

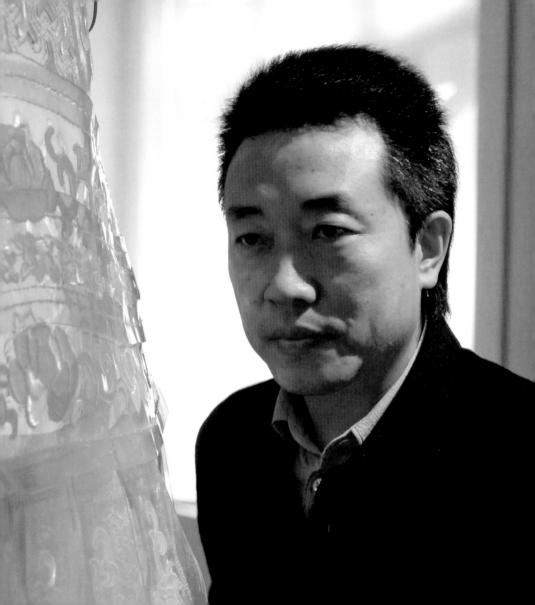

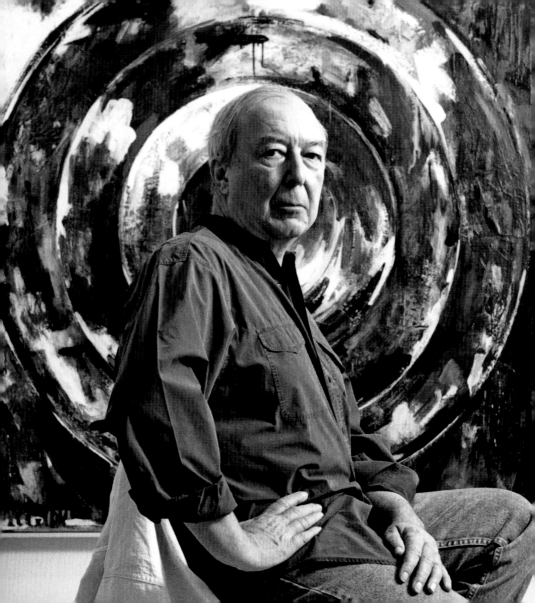

Jasper Johns

Alex Katz

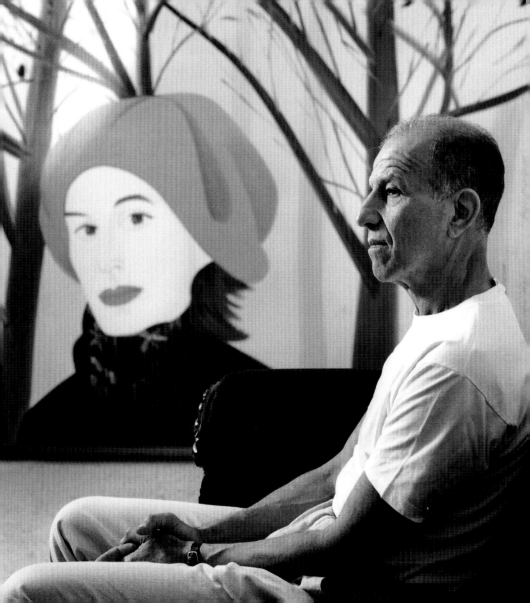

Ellsworth Kelly

Black Relief, 2007

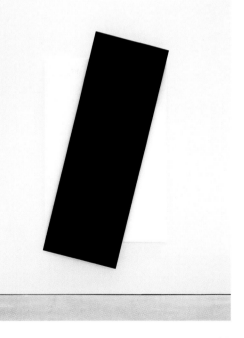

Terence Koh

Untitled 4 (OWL), 2003

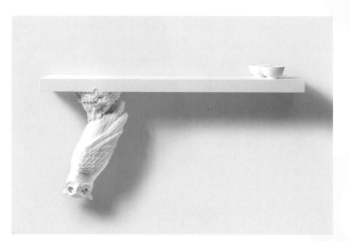

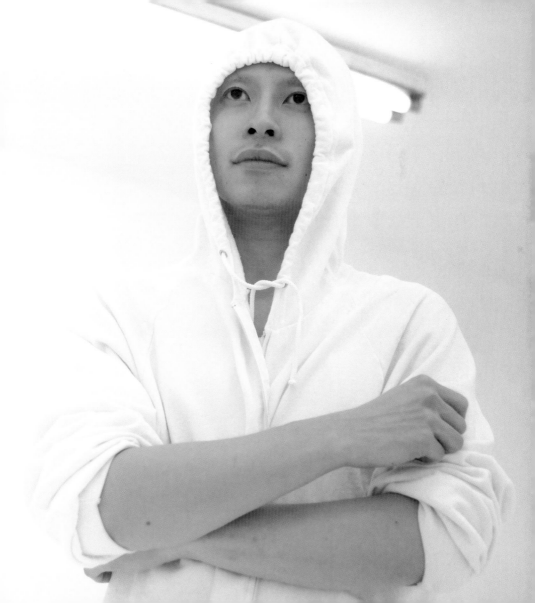

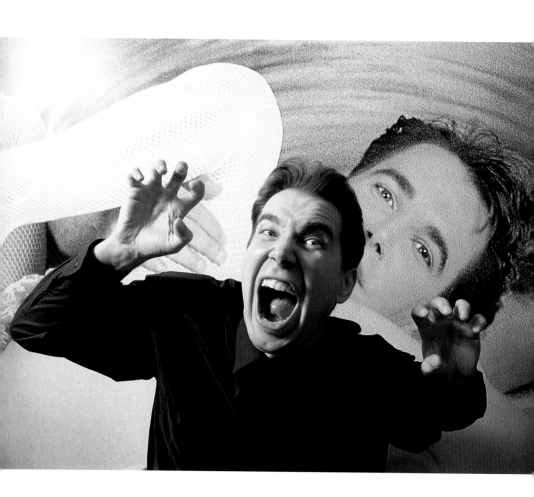

Jeff Koons

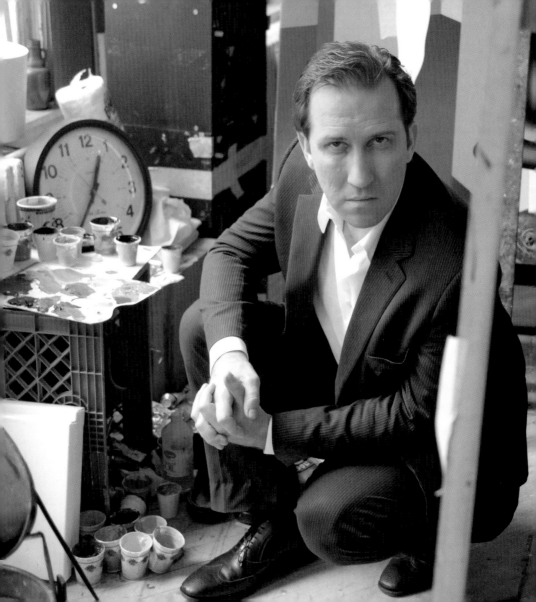

Mark Kostabi

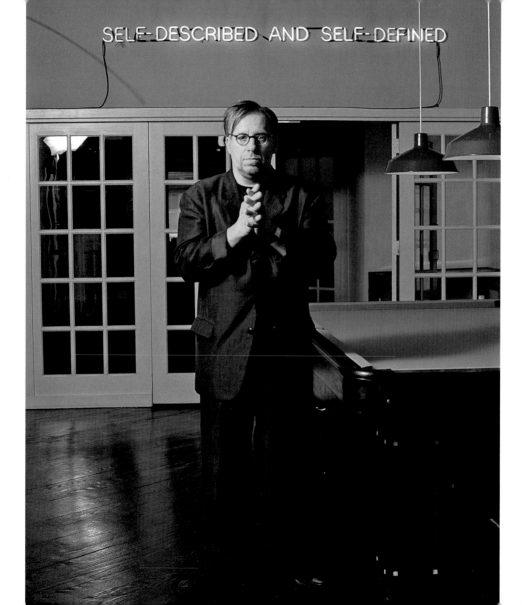

Joseph Kosuth

Four Colors Four Words, 1965

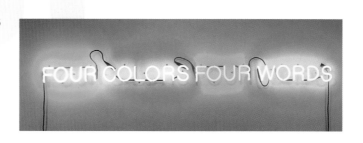

Yayoi Kusama

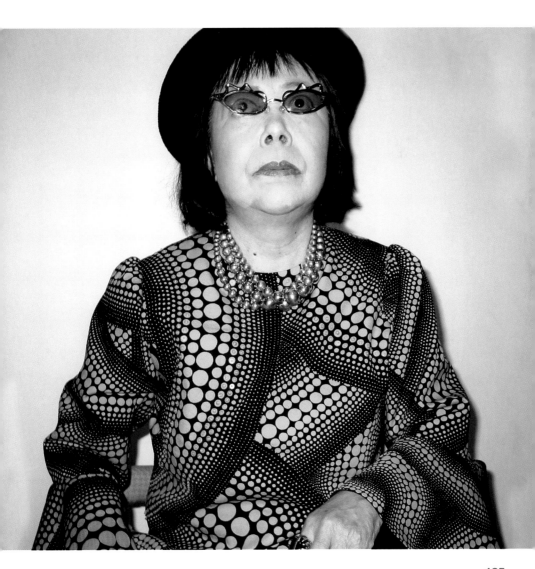

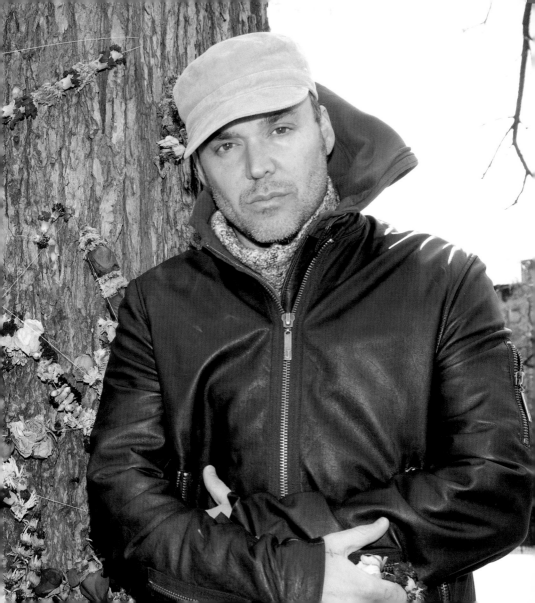

Dave Lachapelle

Abel, 2007

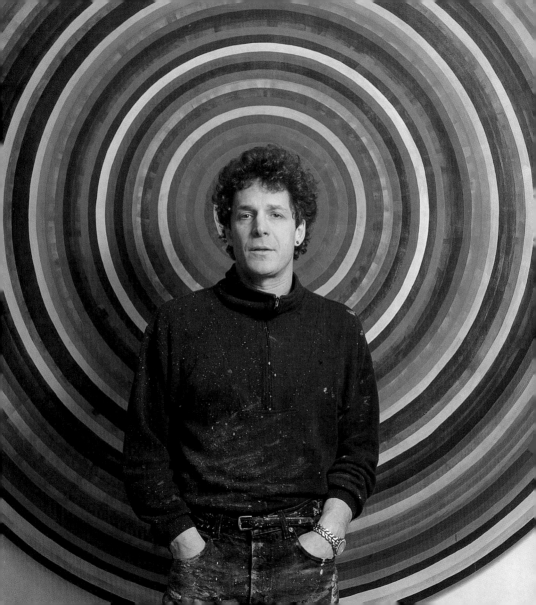

Gary Lang

Native, 1998

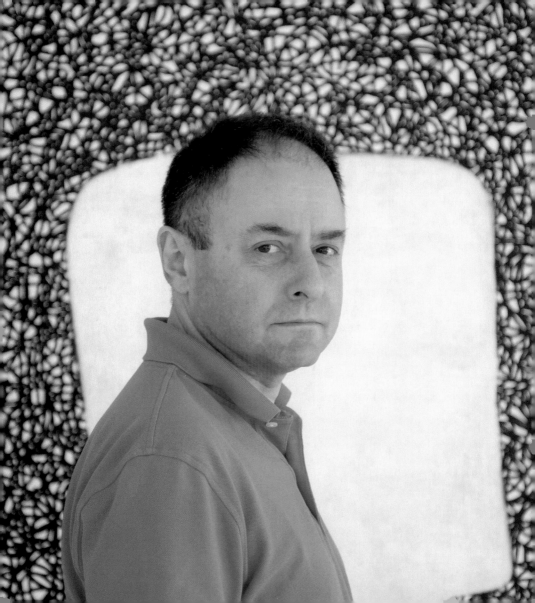

Jonathan Lasker

Marcus Leatherdale

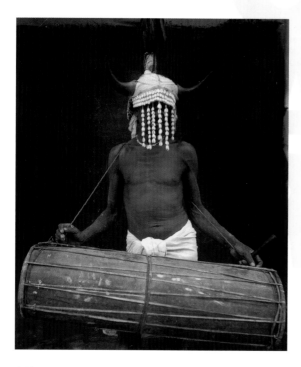

Bison Horn Maria –
Gutrapara, Chhatisjarh

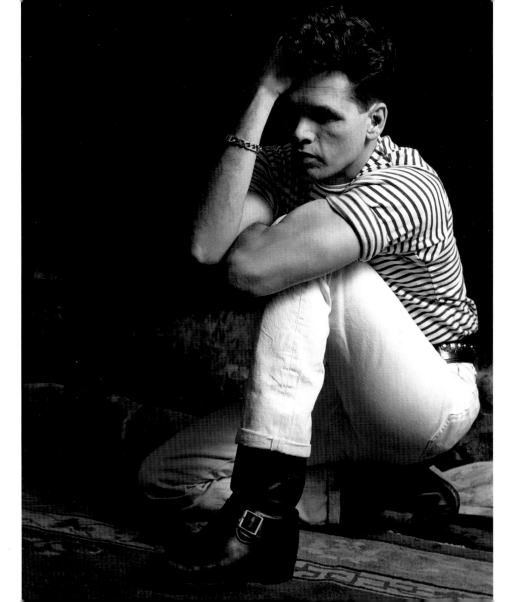

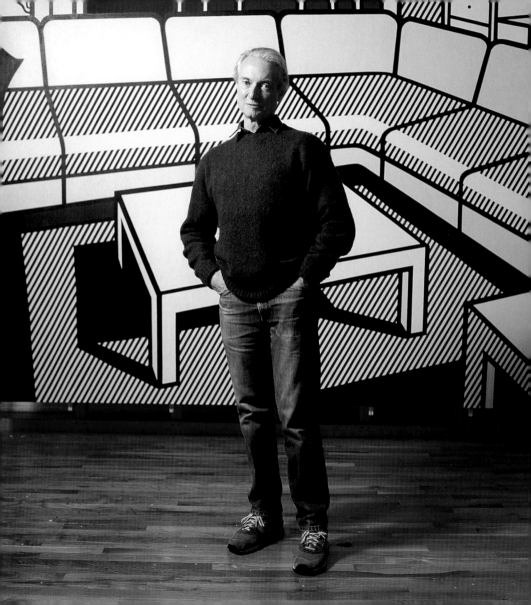

Roy Lichtenstein

Masterpiece, 1962

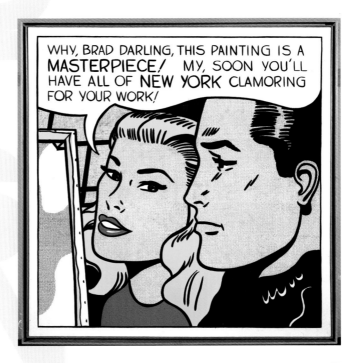

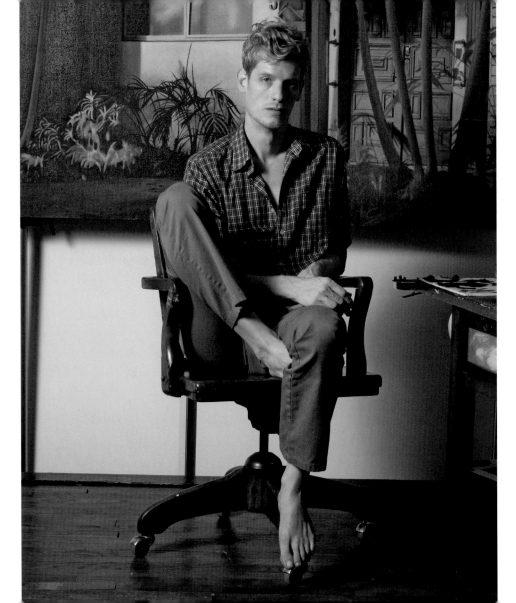

Damian Loeb

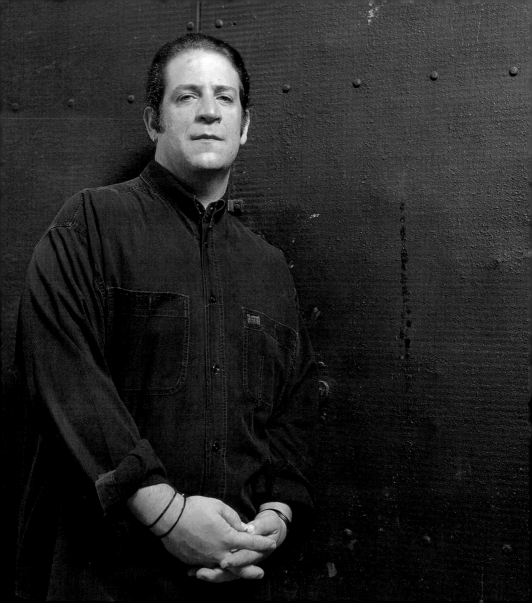

Robert Longo

David Lynch

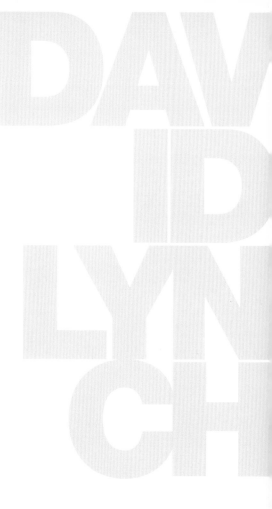

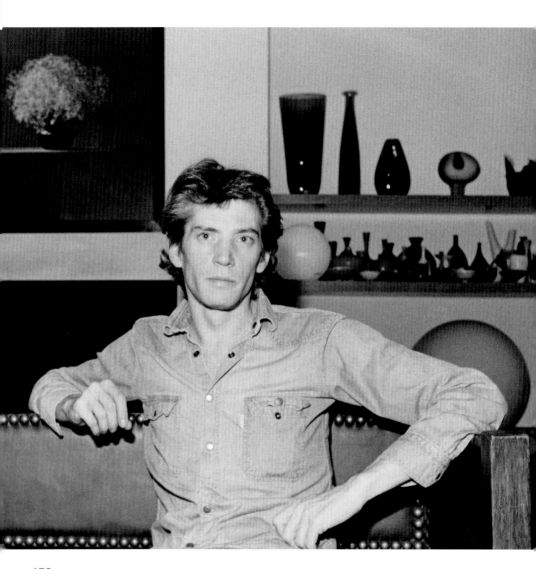

Robert Mapplethorpe

Brice Marden

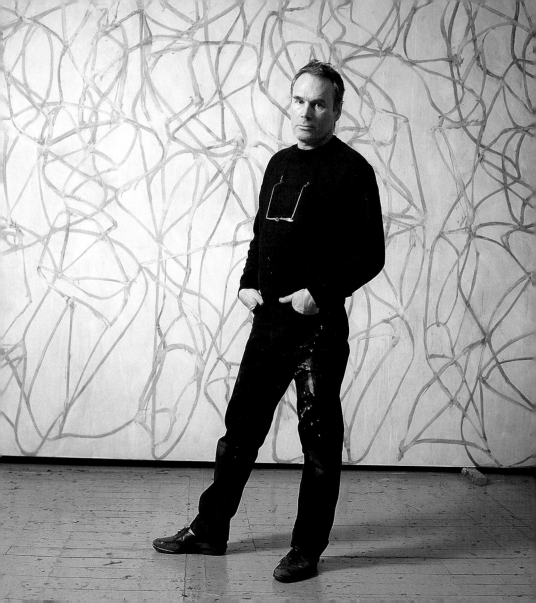

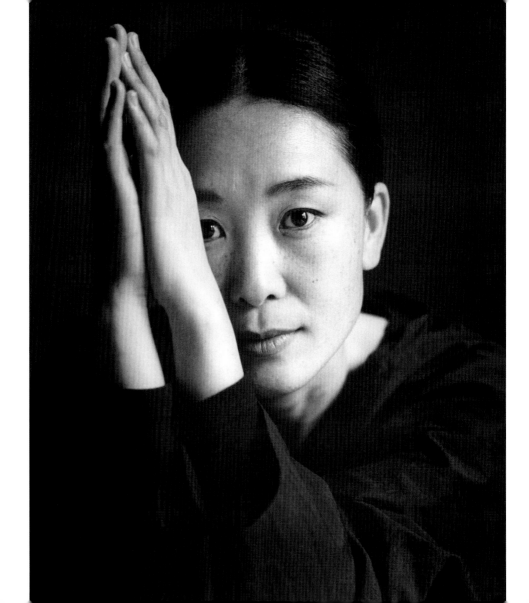

Dodo Ming

Free Element, Plate XXX, 2002

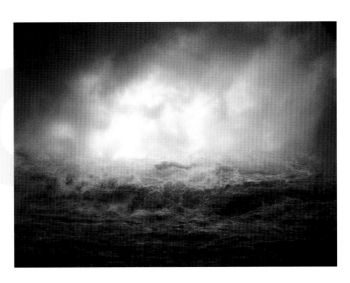

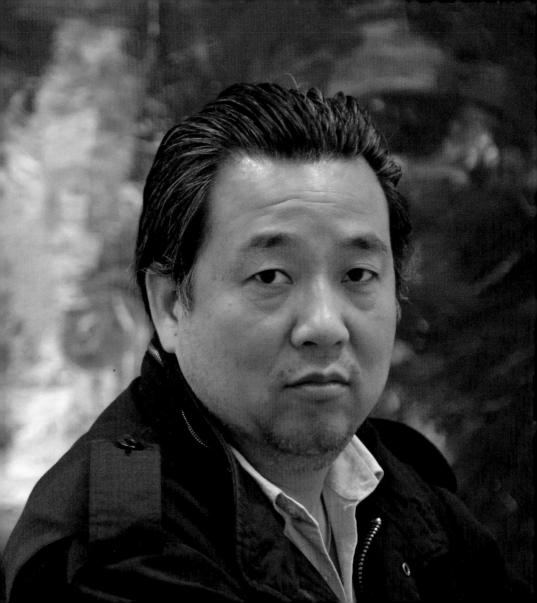

Yan Pei Ming

Black Self-Portrait, 2007

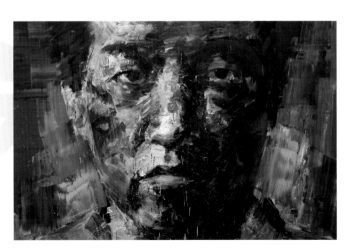

Vik Muniz

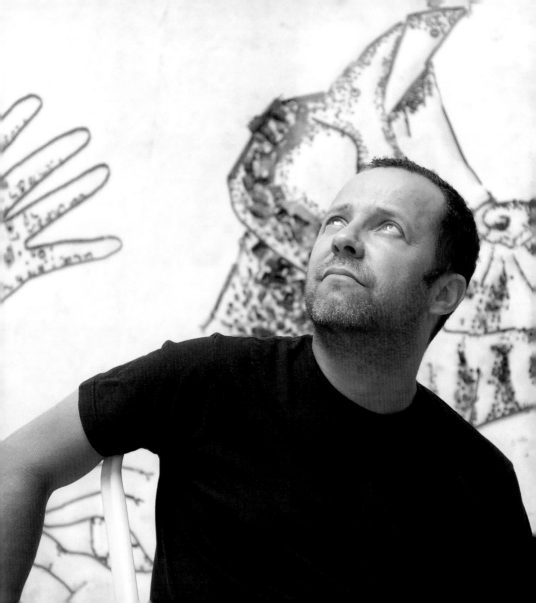

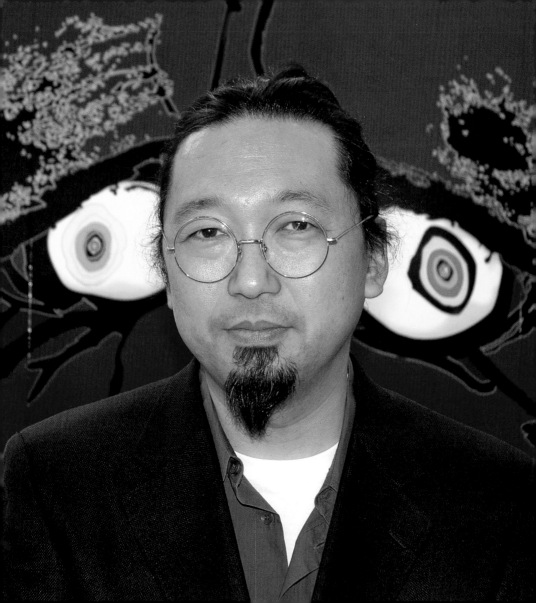

Takashi Murakami

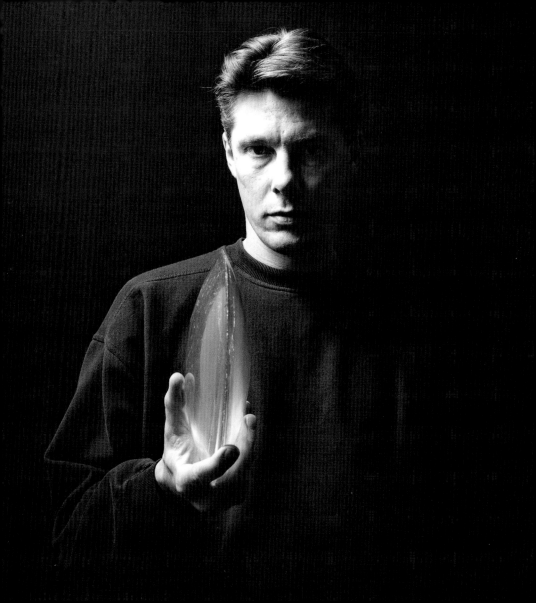

James Nares

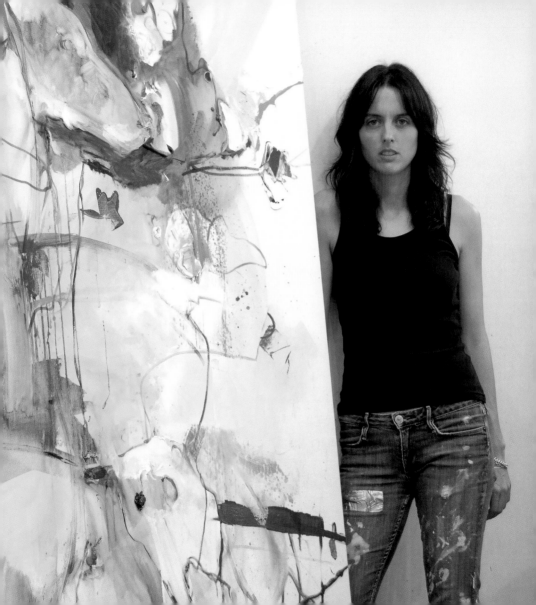

Elizabeth Neel

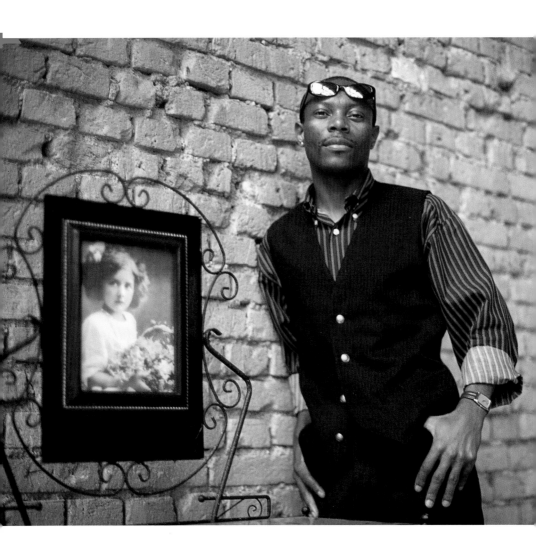

Olu Ogube

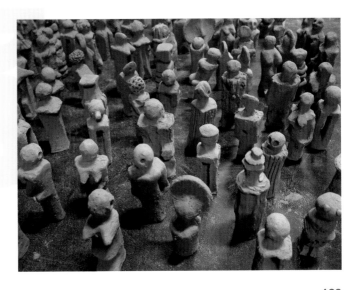

Dennis Oppenheim

Device to Root Out Evil, 1997

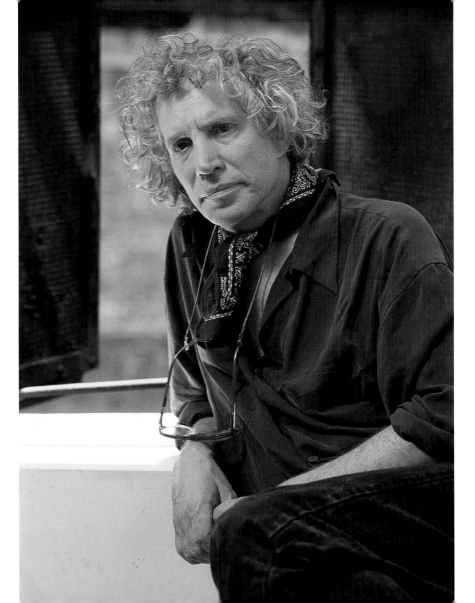

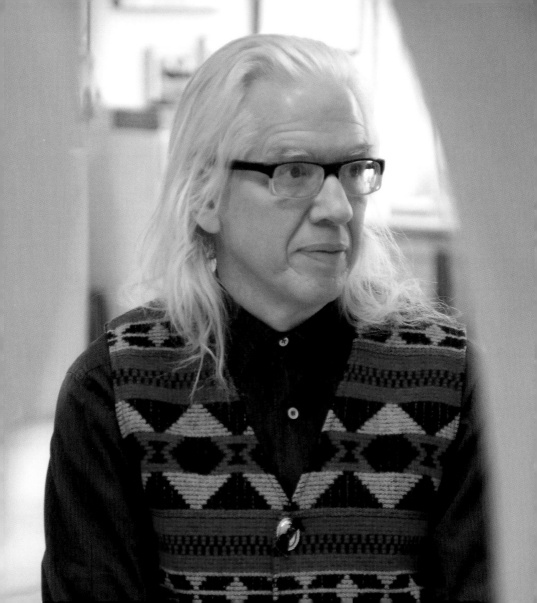

Tom Otterness

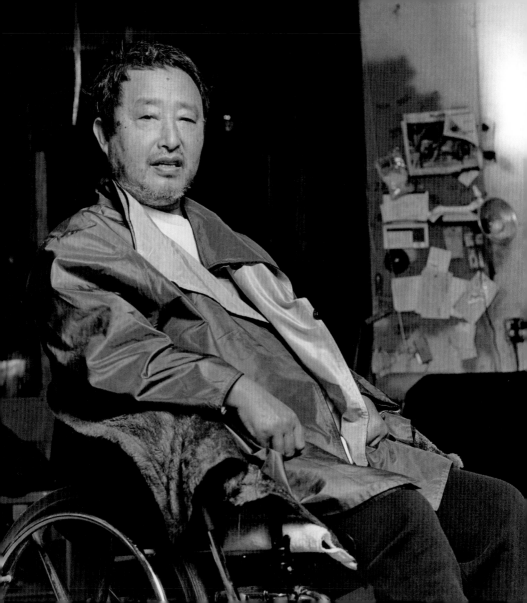

Nam Jun Paik

Phillip Pearlstine

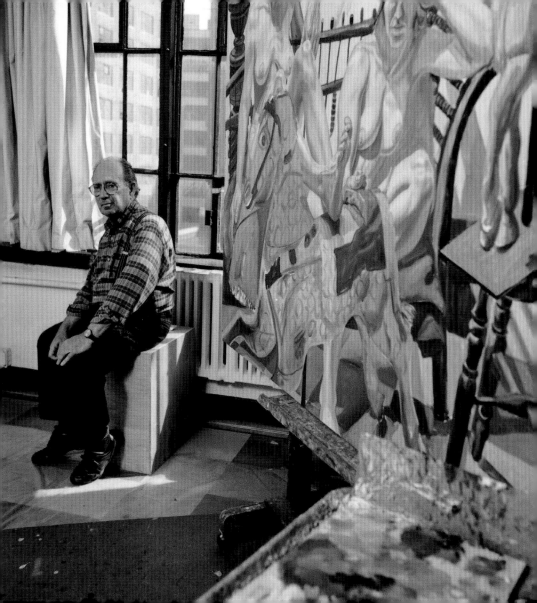

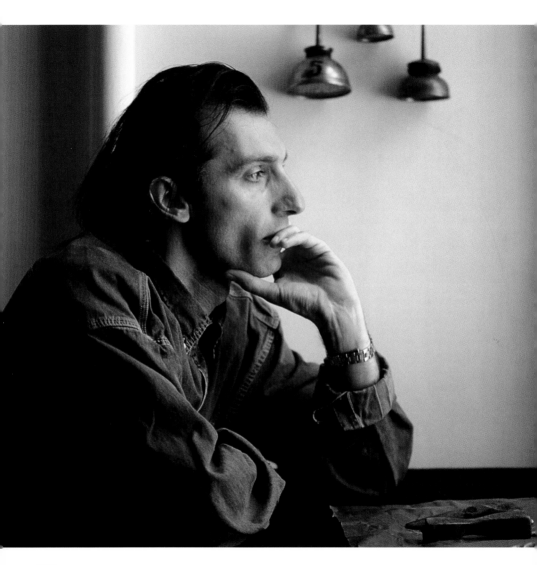

Maurizio Pellegrin

David Perry

DAVID PERRY

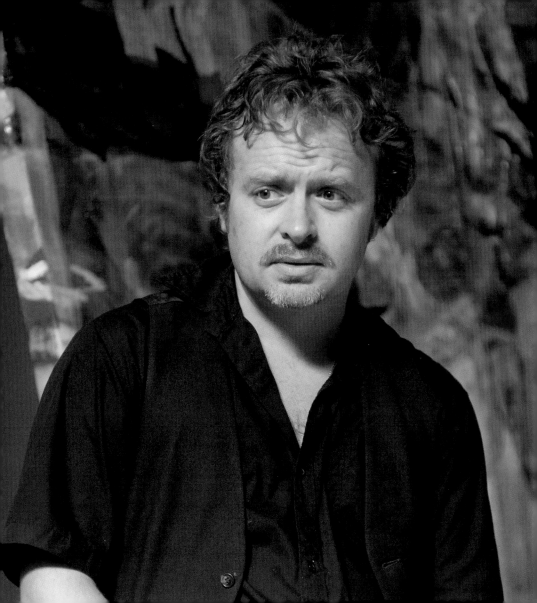

Rona Pondick

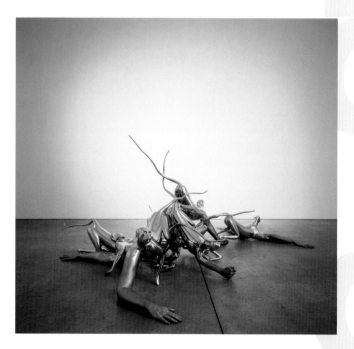

Monkeys, 1998–2001

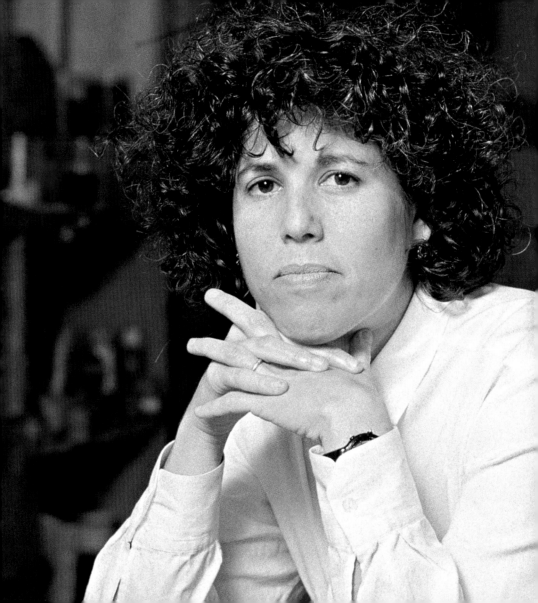

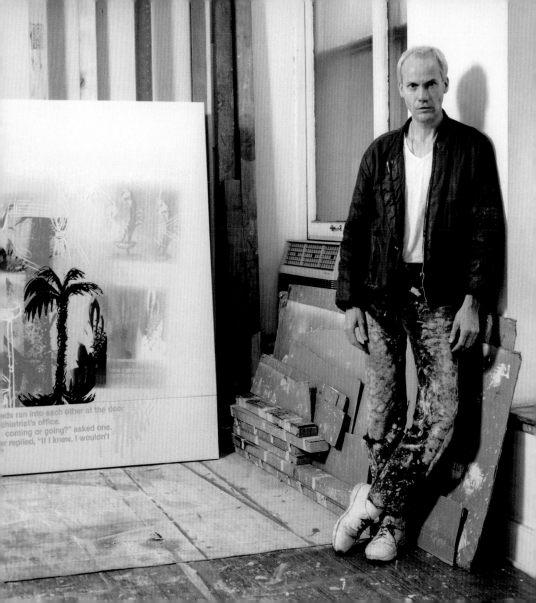

Richard Prince

Untitled (cowboy), 1998

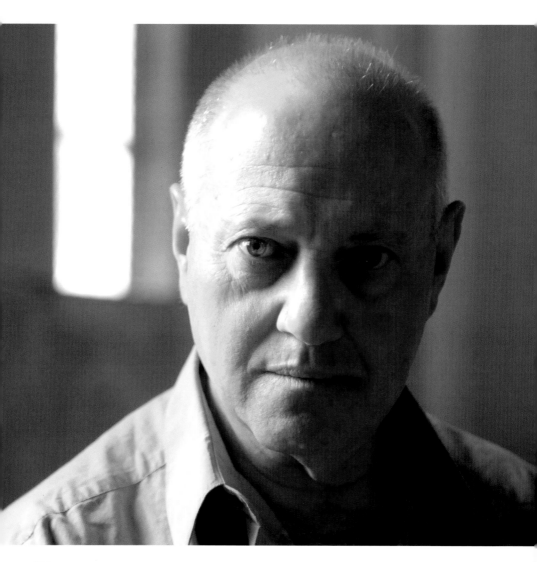

David Rabinowitz

Robert Rauschenberg

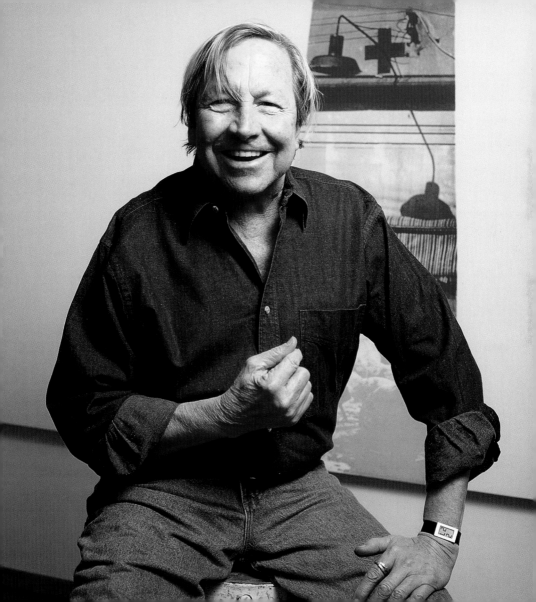

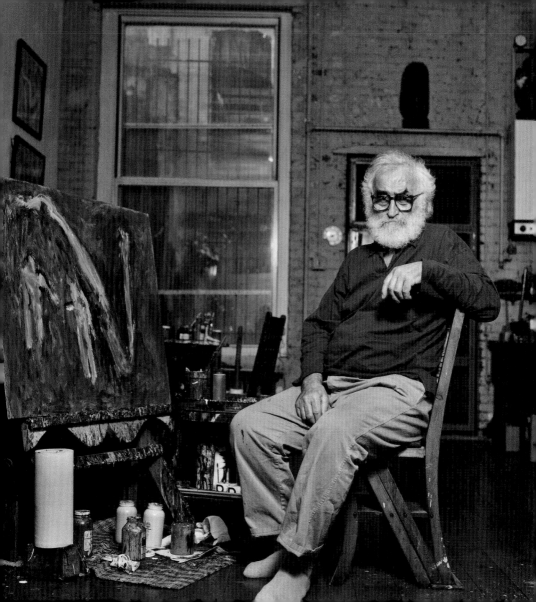

Milton Resnick

Untitled, 1959

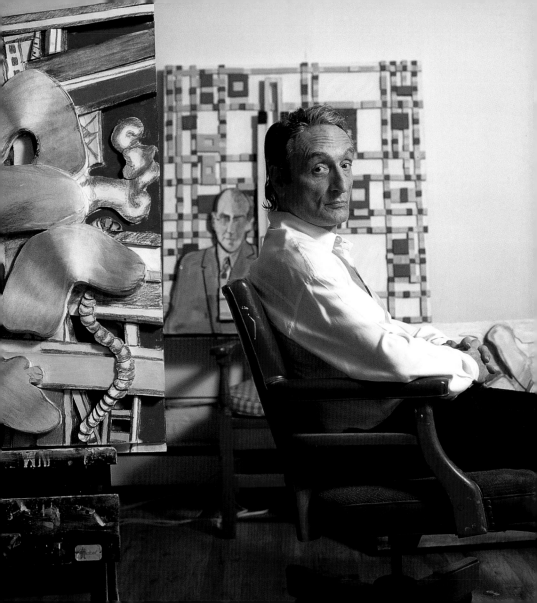

Larry Rivers

Dorothea Rockburne

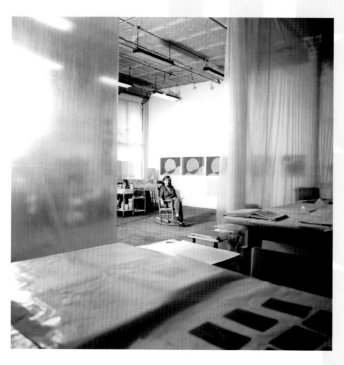

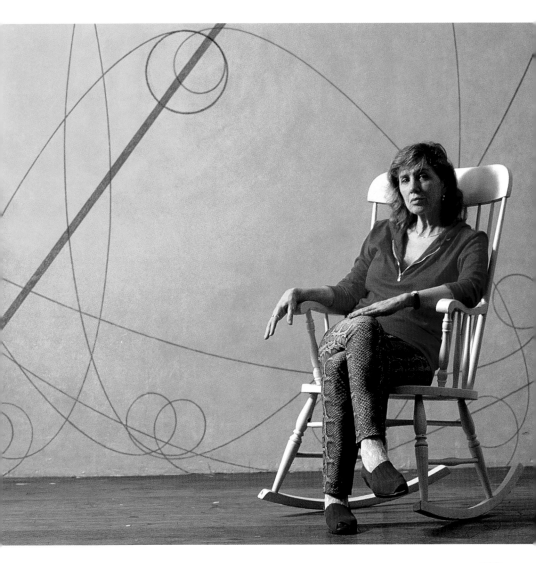

James Rosenquist

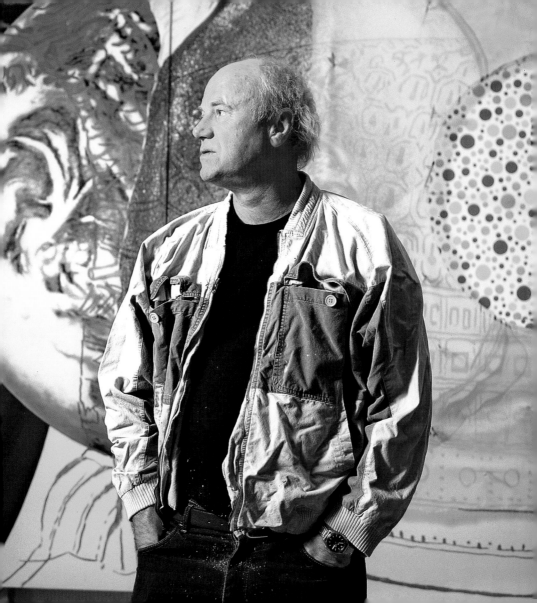

Ed Ruscha

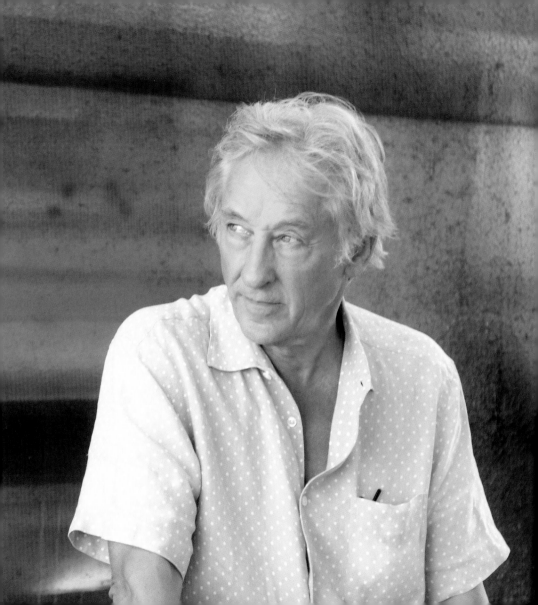

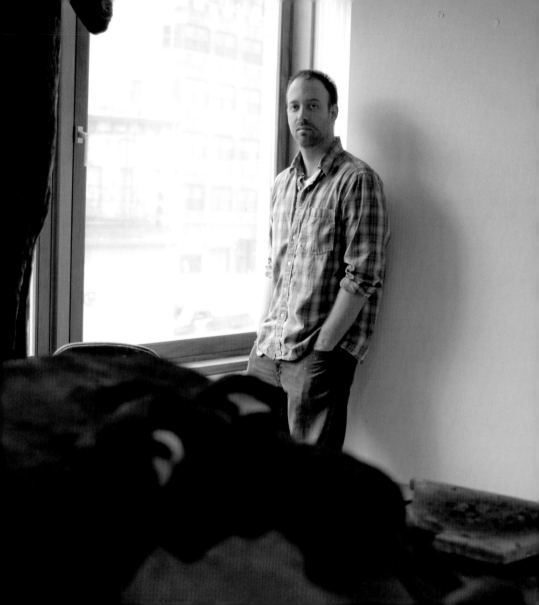

William Ryman

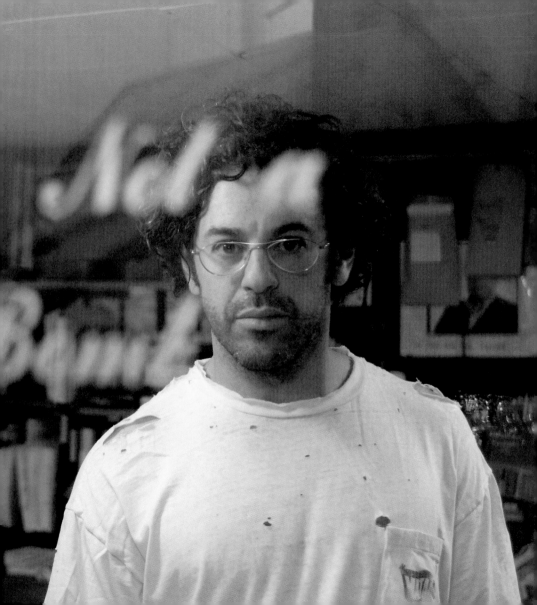

Tom Sachs

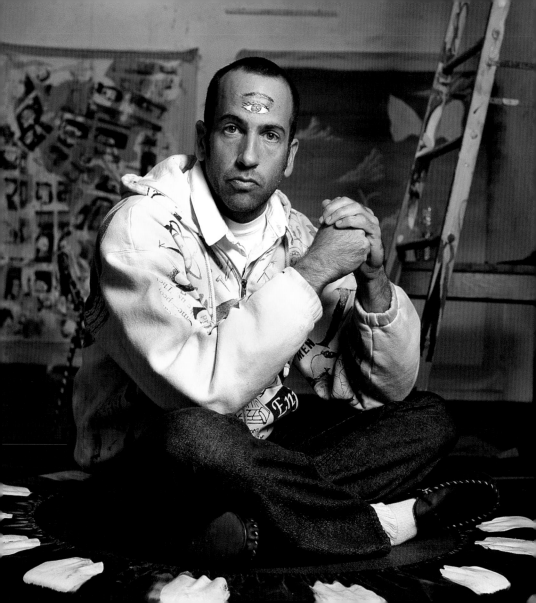

Kenny Scharff

Tang, 2007

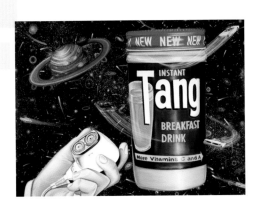

Julian Schnabel

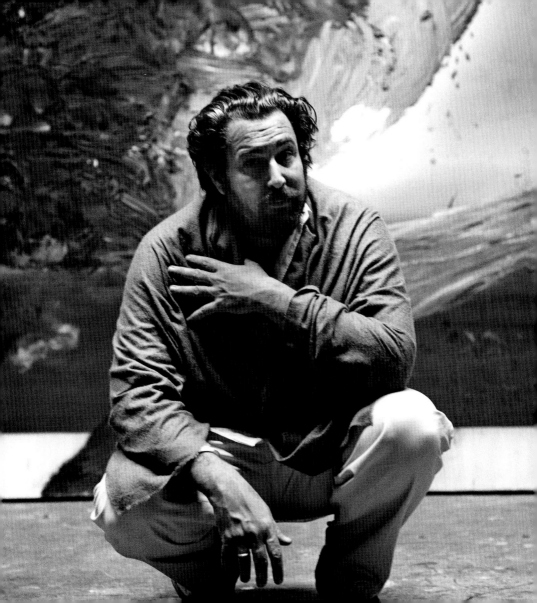

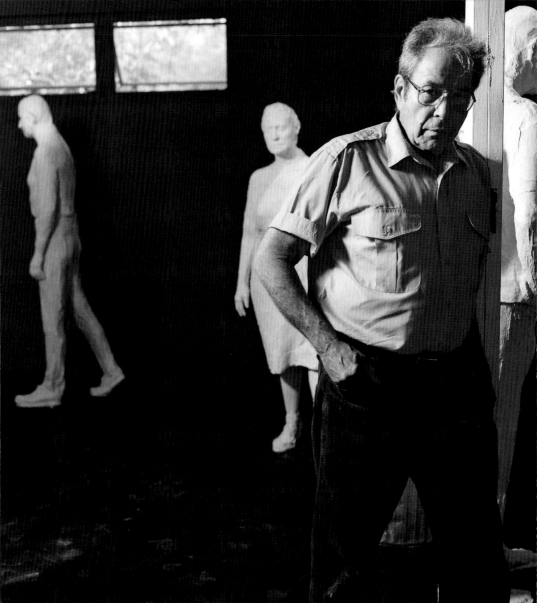

George Segal

Richard Serra

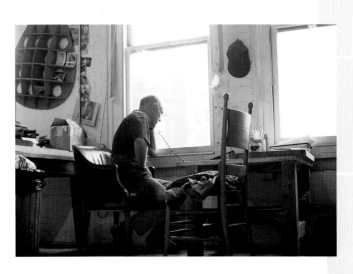

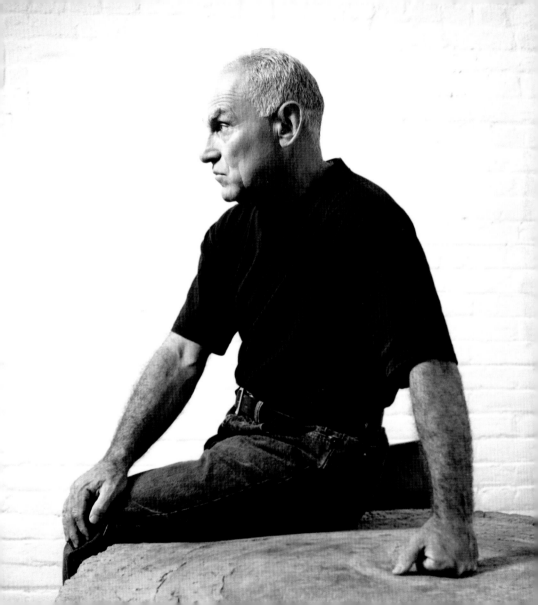

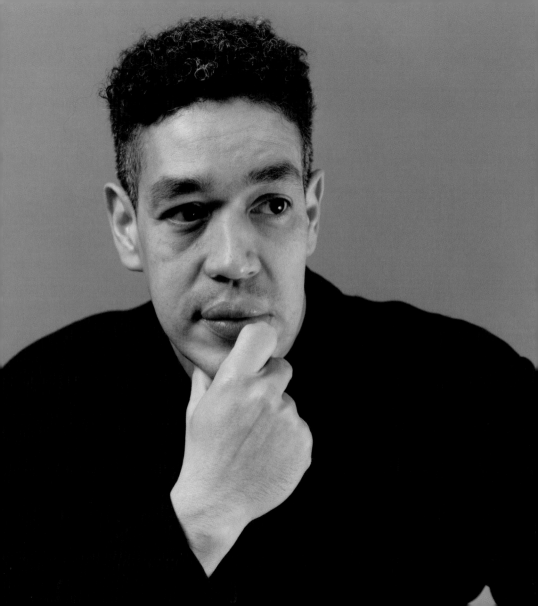

Andres Serrano

Piss Christ, 1987

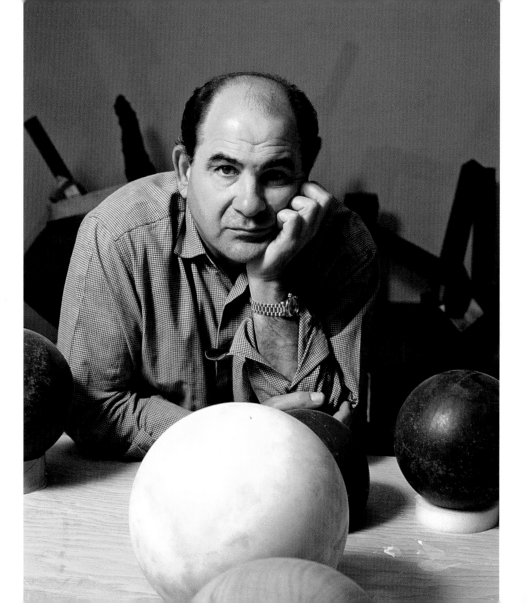

Joel Shapiro

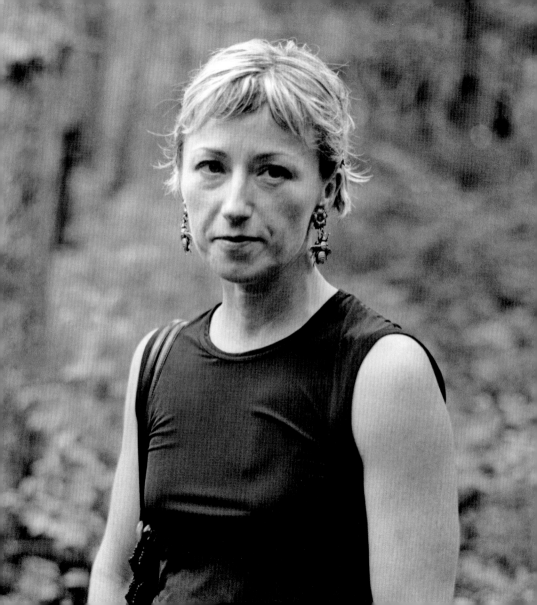

Cindy Sherman

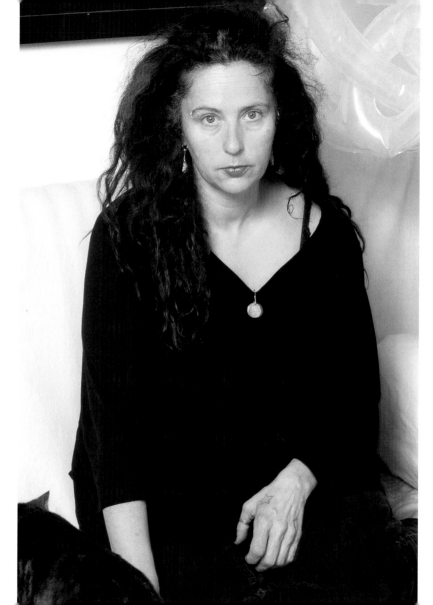

Kiki Smith

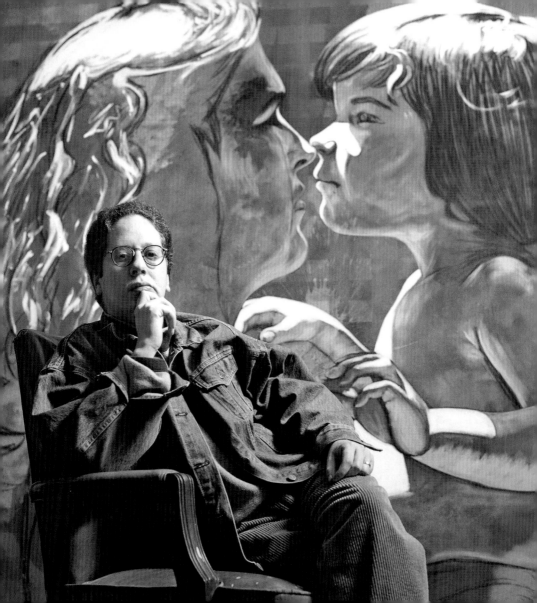

Ray Smith

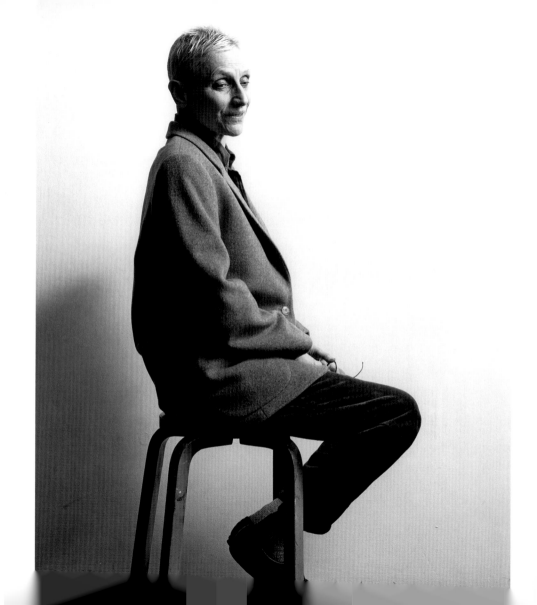

Nancy Spero

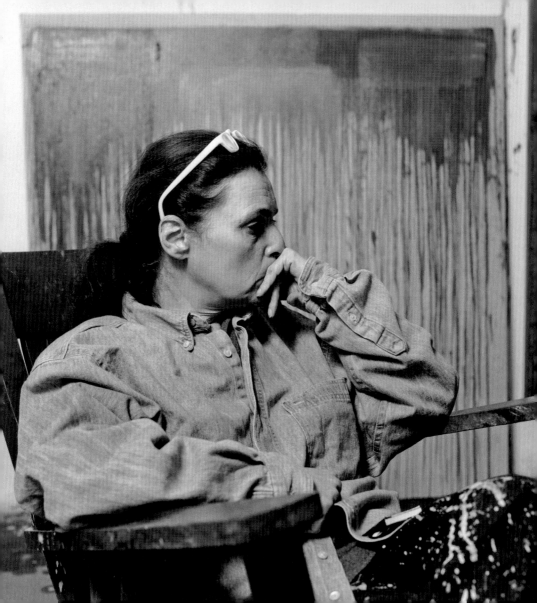

Pat Steir

Sea Storm, 2001

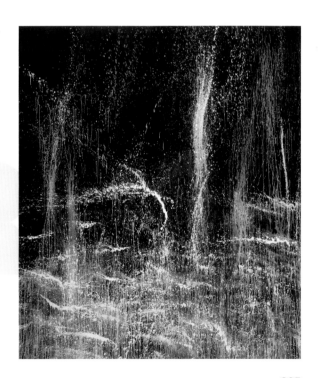

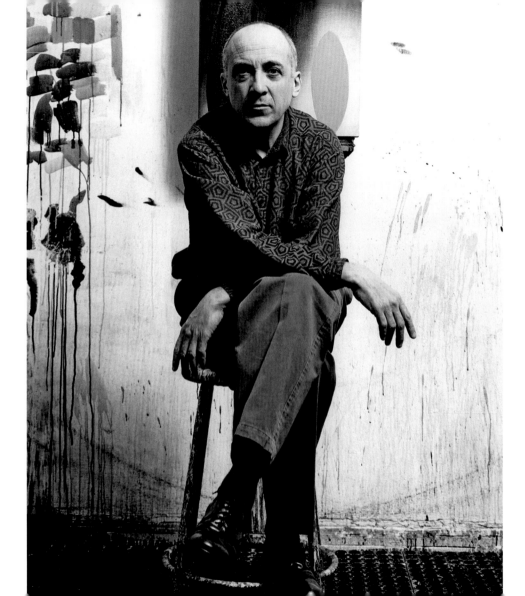

Gary Stephan

Donald Sultan

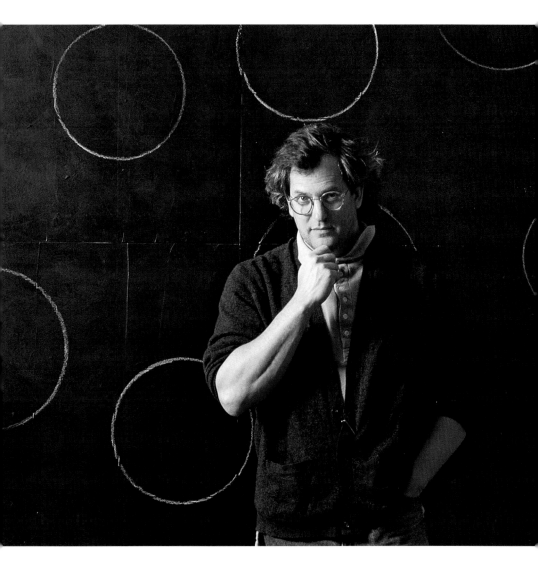

Phillip Taaffe

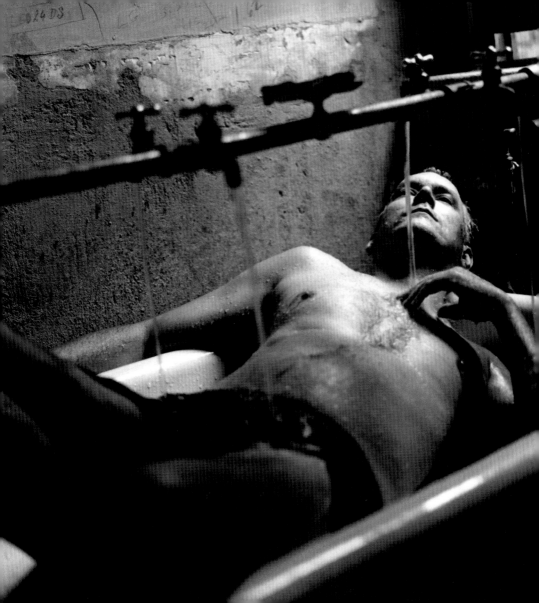

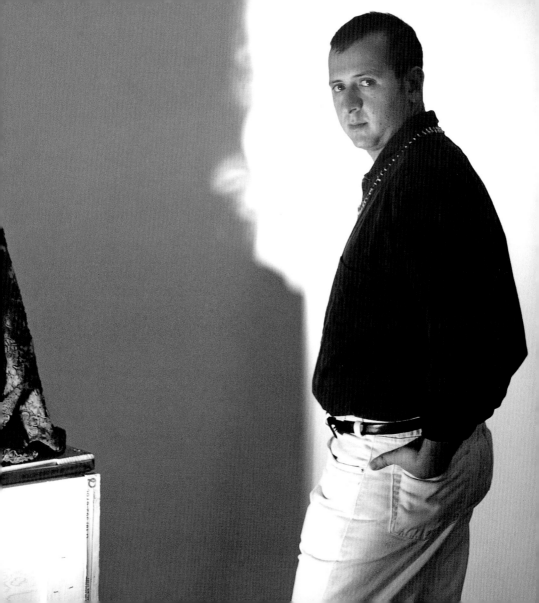

Mayer Vaisman

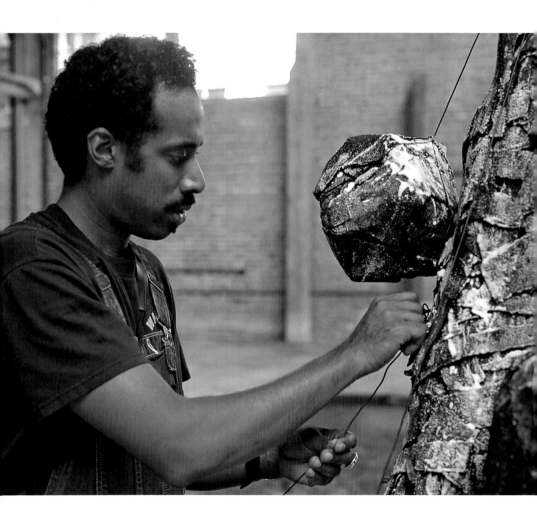

Nari Ward

Glory, 2004

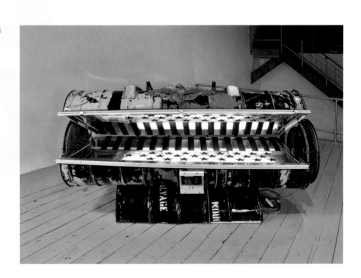

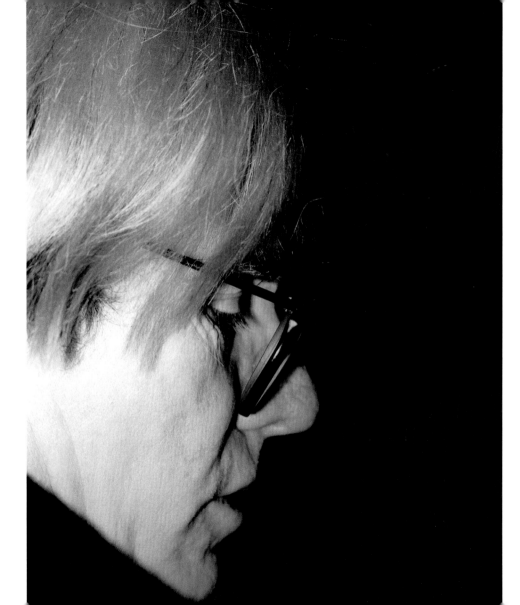

Andy Warhol

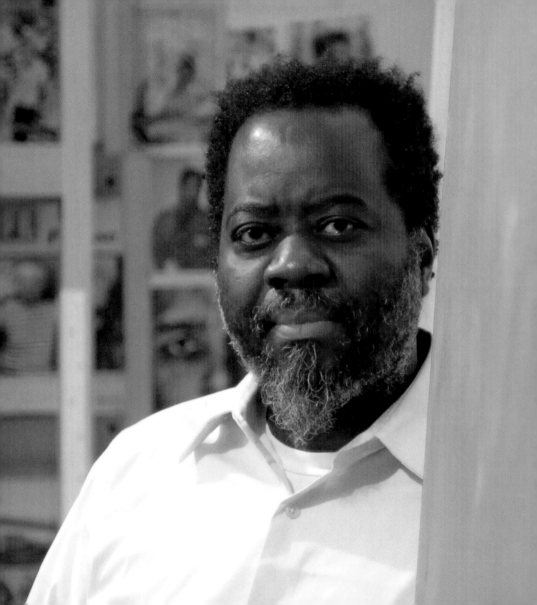

Ouattara Watts

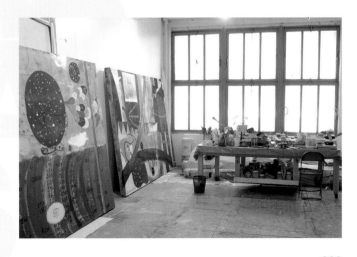

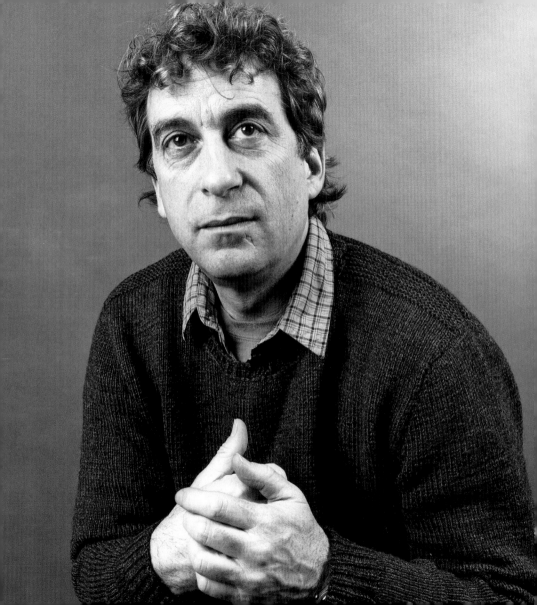

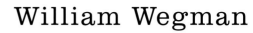

William Wegman

Lawrence Weiner

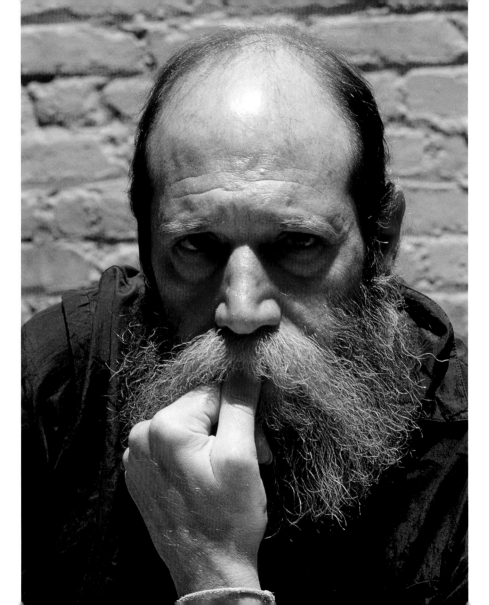

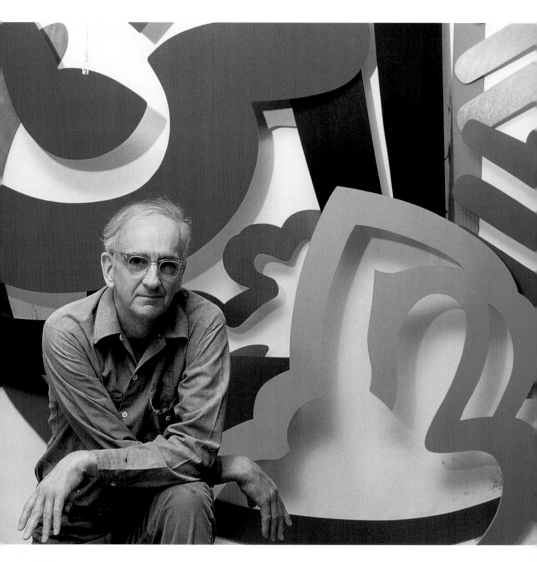

Tom Wesselman

Jackie Winsor

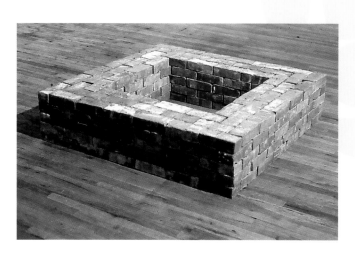

Brick Square, 1971

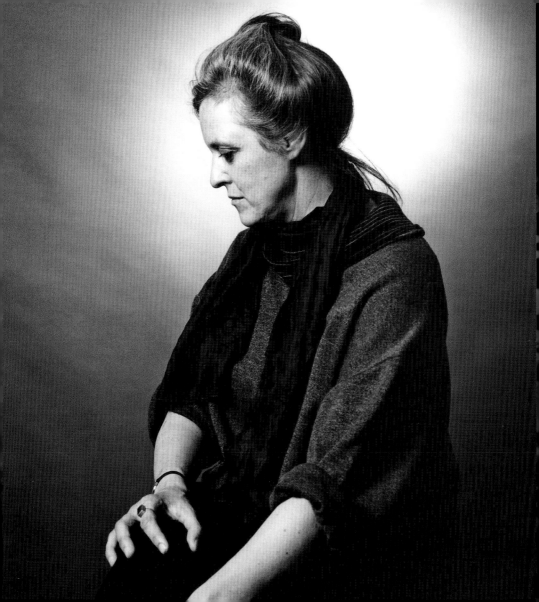

Terry Winters

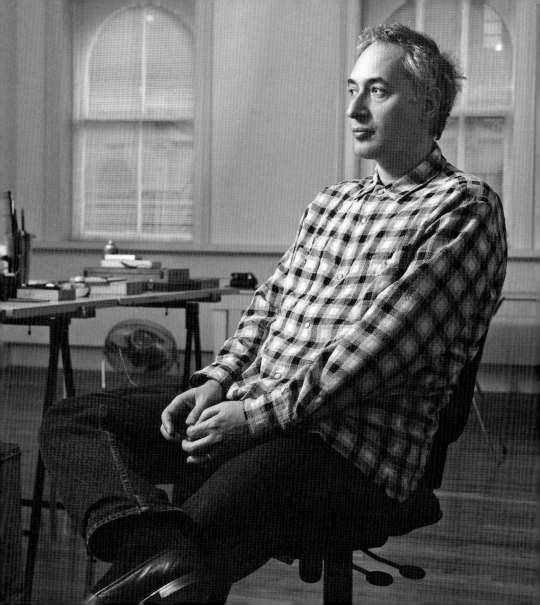

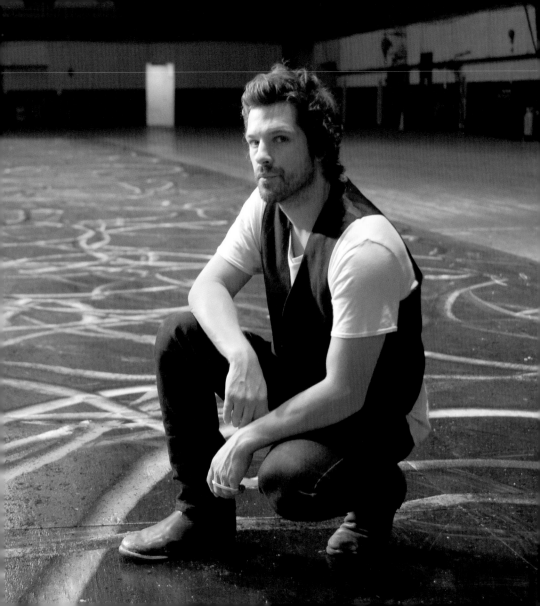

Aaron Young

Chen Zhen

Artwork Credits

Marina Abramović

Thomas Lips, 1975/2005. Framed chromogenic print, 65 x 51½ inches (165.1 x 130.8 cm) framed. Copyright Marina Abramović. Courtesy Sean Kelly Gallery, New York.

Vito Acconci

Mur Island, Graz, Austria, 2001–03. Photography by Harry Schiffer.

Ghada Amer

Heather's Degrade, 2006. Embroidery and gel medium on canvas, 78 x 62 inches (198.1 x 157.5 cm). Copyright Ghada Amer. Courtesy Gogosian Gallery. Photography by Robert McKeever.

Alexandre Arrachea

Arena (1), 2005. Plastic chairs and ball, 43 x 43 inches (109.2 x 109.2 cm). Courtesy Magnan Projects, New York City.

Pierre Bismuth

Most Wanted Men/NYC (Jeff Koons), 2007. C-print/cintra, spray paint/Plexiglas, 48 x 79 inches (122 cm x 201 cm). Courtesy Mary Boone Gallery, New York City.

Louise Bourgeois

J'y suis, j'y reste, 1990. Pink marble, glass and metal, 35 x 40½ x 31 inches (88.9 x 102.8 x 78.7 cm). Private collection. Courtesy Cheim & Read, New York. Photography by Jochen Littkemann.

Nassos Daphnis

PX-18-69, 1969. Enamel on Plexiglas, 30 x 30 inches (76.2 x 76.2 cm). Courtesy Anita Shapolsky Gallery.

William Eggleston

Untitled, (Store Parking Lot) From Lost And Found, 1965–74. Dye-transfer print, 16 x 20 inches (40.6 x 50.8 cm). Edition 1/12. Copyright 2007 Eggleston Artistic Trust. Courtesy Cheim & Read, New York.

Eric Fischl

The Bed, The Chair, Jetlag, 2000. Oil on linen, 85 x 105 inches (215.9 x 266.7 cm). Courtesy the Artist and Mary Boone Gallery, New York City.

Gilbert & George

Son of a God, 2005. 118⁹⁄₁₀ x 150 inches (302 x 381 cm). Courtesy the Artists.

Allen Ginsberg

Window, 1984. Copyright Allen Ginsberg Estate.

Leon Golub

Prometheus II, 1998. Acrylic on linen, 119 x 97 inches (302.3 x 246.8 cm). Collection: The National Gallery of Ottawa. Courtesy Ronald Feldman Fine Arts, New York.

Wenda Gu

Installation at Dartmouth College. Courtesy Dartmouth College/Jeffrey Nintzel.

Damien Hirst

The Physical Impossibility of Death in the Mind of Someone Living, 1991. Glass, steel, silicone, shark and 5% formaldehyde solution, 84 x 252 x 84 inches (213.4 x 640.1 x 213.4 cm). Copyright The Artist. Photography by Antony Oliver. Courtesy Jay Jopling/ White Cube (London).

Zhang Huan

Buddha Never Down, 2003. Painted aluminum body and steel structure. Courtesy the Artist.

Ellsworth Kelly

Black Relief, 2007. Oil on canvas, two joined panels, 103¼ x 56⅝ x 2¾ inches (262.3 x 143.8 x 7 cm). Private collection. Photography by Jerry L. Thompson, courtesy the Artist. Copyright Ellsworth Kelly.

Terence Koh

Untitled 4 (OWL), 2003. Plastic owl, two 440 cubic zirconia stones with engraved text (William), acrylic paint, glue adhesive, flat household paint on wood shelf. Approx. 43¼ x 24 x 10¼ inches (109.9 x 61 x 26 cm). Edition of 3 + 2 AP. Courtesy Peres Projects, Los Angeles, Berlin.

Joseph Kosuth

Four Colors Four Words, 1965. Glass, neon with transformer, and certificate of authenticity, unique, 5 x 73 x 2 inches (12.7 x 185.4 x 5 cm). Copyright Joseph Kosuth. Courtesy Sean Kelly Gallery, New York.

David Lachapelle
Abel, 2007. Digital C-print. Courtesy the Artist.

Marcus Leatherdale
Bison Horn Maria – Gutrapara, Chhatisjarh.
Courtesy the Artist.

Gary Lang
Native, 1998. Acrylic on canvas. Courtesy the Artist.

Roy Lichtenstein
Masterpiece, 1962. Oil on canvas, 54 x 54 inches
(137.2 x 137.2 cm). Courtesy Lichenstein Foundation

Dodo Ming
Free Element, Plate XXX, 2002. Gelatin silver print,
16 x 20 inches (40.6 x 50.8 cm), edition 15; and C-
print, 30 x 40 inches (76.2 x 101.6 cm), edition 10.
Courtesy Laurence Miller Gallery.

Yan Pei Ming
Black Self-Portrait, 2007. Oil on canvas, 137⅕ x 137⅕
inches (350 x 350 cm). Courtesy David Zwirner
Gallery, New York City.

Dennis Oppenheim
Device to Root Out Evil, 1997. Galvanized structural
steel, anodized perforated aluminum, transparent red
Venetian glass, concrete foundations, 20 x 15 x 8
inches (50 x 38 x 20 cm). Collection of The Denver
Art Museum, Denver, Colorado. Gift of Ginny
Williams. Photography by Edward Smith.

Richard Prince
Untitled (cowboy), 1998. Ektacolor photograph,
50 x 76 inches (127 x 193 cm), 61 x 88¼ inches
(154.9 x 224.2 cm) framed. Edition of 2 + 1 AP.
Copyright Richard Prince. Courtesy Gladstone
Gallery, New York.

Rona Pondick
Monkeys, 1998–2001. Stainless steel, 41⅕ x 66 x
85½ inches (104.6 x 167.6 x 217.2 cm). Edition of
6 + 1 AP. Courtesy Sonnabend Gallery New York City.

Milton Resnick
Untitled, 1959. Oil on canvas, 70 x 49¾ inches
(177.8 x 126.4 cm). Courtesy Cheim & Read,
New York.

Kenny Scharff
Tang, 2007. Oil and glitter on canvas, 108 x 120
inches (274.3 x 304.8 cm). Courtesy Paul Kasmin
Gallery, New York City.

Andres Serrano
Piss Christ, 1987. Cibachrome, silicon, Plexiglas,
woodframe, 60 x 40 inches (152.4 x 101.6 cm)
65 x 45½ inches (165.1 x 114.6 cm) framed.
Courtesy the Artist.

Pat Steir
Sea Storm, 2001. Oil on canvas, 102 x 87 inches
(259.1 x 221 cm). Courtesy Cheim & Read, New York.

Nari Ward
Glory, 2004. Oil barrel, fluorescent and ultraviolet
tubes, computers parts, Plexiglas, fan, camera.
Variable dimensions. Courtesy Deitch Projects.

Jackie Winsor
Brick Square, 1971. Stacked bricks,15 x 50 x 50
inches (38.1 x 127 x 127 cm). Courtesy Paula Cooper
Gallery.

Acknowledgments

I would like thank all of the artists, galleries, and gallery staff who assisted me in compiling the material for this book.

My thanks also go out to the following people for their ongoing encouragement and support for this project:

David A. Ross and Judd Tully
Paul Brach
Alessina Brooks, Paul Latham, Andrew Hall, Joe Boschetti,
and the staff at The Images Publishing Group
Scott Duncan Films and Ncyclomedia, NY
Franco Staffa, Gerrit Sievert, William Scalia, and Anna Rosencrantz
Christine Wächter at Winston Wächter Fine Art
My son Max
Mario, Totoni, Gina, Caterina, and their families

In memoriam of Giuseppina, Pasquale, and Gonario Piras